Centennial Celebration
1907 - 2007

To our Sterling Silver Patrons
With appreciation from
The Masters and Board of Governors
Millbrook Hunt

# With Brush and Bridle

## Richard Newton, Jr.—Artist and Equestrian

John J. Head

With a Foreword by George A. "Frolic" Weymouth
and Nicholas Prychodko, Editor.

ELLERSLIE PRESS
AMERICAN SPORTING ART PROJECTS
P.O. BOX 86, WASHINGTON, VA 22747

Head, John J.
With Brush and Bridle: Richard Newton, Jr.—Artist and Equestrian
John J. Head, with a foreword by George A. "Frolic" Weymouth and Nicholas Prychodko

Edited by Nicholas Prychodko
Designed by Charles Sheblom

ISBN: 0-9785686-0-5

**Special Credits**

The Long Island Museum of American Art, History & Carriages: *Mrs. James H. Blackwell*; Portrait of *John R. Townsend on Greek Dollar*

Peter A. Juley & Son Collection (Smithsonian American Art Museum, Smithsonian Institution): *Master Luther Tucker* (J0024488); *Orange County Stafford '99* (J0118446); *Orange County Ranta* (J0011169)

The Jockey Club: *Rock Sand*

Photo courtesy of American Heritage: *Reginald Rives*

Editorial note: Quotations from original sources have not been altered to reflect contemporary usage, or to correct apparent typographical errors.

Printed in China

# Contents

# Acknowledgements

Early in the winter of 1999, a painting by Richard Newton, Jr., piqued my interest. As the new director of the Museum of Hounds and Hunting, I had just begun preparing for our spring opening and was working alone in the gallery, something I have always enjoyed doing. Intrigued by Newton's narrative portrayal of a foxhunting scene, I was, however, frustrated by the dearth of information about the artist's life and work. The museum's collection provided few clues: a single painting by Newton, and a file that contained nothing but a few donor records. Thus it came about that, having caught the faint echoes of hounds speaking from the remote past, I decided to follow them wherever they might lead and prepared for an adventurous chase.

Highpoints of my adventures researching the life and work of Mr. Newton found their way into my monthly reports to the Advisory Committee of the Museum of Hounds and Hunting. Soon these illustrious members of the hunting community came to share my conviction that the paintings of America's only MFH who was also an accomplished artist merited rediscovery. With their enthusiastic support, I was able to organize an exhibition of some of Newton's paintings that I had found early in my quest—the first public showing of his works since 1916 at the Ralston Galleries in New York. Having secured the loan of each painting I had discovered to date, the museum opened its 2002 season with eleven canvases by the artist. Too soon for the curator, the paintings were returned to their owners, but disappointment at their removal was tempered with the satisfaction derived from a unique and successful show, spurring me on to continue the hunt.

My efforts benefited immeasurably from the advocacy of institutions and individuals in the foxhunting community. Prominent among them are the National Sporting Library, in Middleburg, VA, America's leading research center devoted to horse and field sports; and Old Westbury Gardens, in Old Westbury, NY, a locale featured in Newton's equestrian portraits. Both have kindly agreed to endorse my book.

Picture a comfortable, state-of-the-art facility located in the beautiful horse country of Middleburg, with a cordial and expert staff to help navigate a collection without parallel in its field, and you begin to understand what makes the National Sporting Library a special place for scholars. Nancy H. Parsons,

President and CEO, Lisa Campbell, Librarian, and Louisa Woodville and Elizabeth Manierre, are to be commended for their support and encouragement. I am especially proud of the interest that the National Sporting Library has taken in the preparation of this book, as it is not only a prestigious organization located in a beautiful building in Virginia's premier hunt country, but it is also closely associated with Mr. Paul Mellon, who was America's foremost collector of equestrian art of all kinds. He is remembered fondly by all collectors of the genre and for his generosity to so many museums in this country, including the National Sporting Library.

At Old Westbury Gardens, one can encounter the grandeur and beauty of Long Island's past. "The Garden," as locals call the Phipps mansion in Westbury, Long Island, was built in the early years of the last century to replicate John Phipps' gardens in his native England, with an even larger and more imposing dwelling than the family seat in England. Old Westbury Gardens today is one of the very few historic homes in America that contain their original furnishings, children's toys, books, etc. Today it is headed by Mrs. Howard Phipps, Jr., Chairman, to whom I would like to offer special thanks, as well as to her associates Mrs. James M. Large, Jr., President, and Mrs. Jane S. Greenleaf, Trustee. Richard Newton, Jr., painted at the Old Westbury pond, once the home country of the Meadow Brook Hounds. The artist's own pack, the Suffolk Hounds, hunted the territory further east, from Southampton to Montauk Point, between 1902 and 1941.

Early in my chase, a veritable hunting party of helpful people began to form, arranging themselves— in my mind, at least—in alphabetic order, not unlike the verses of Grace Newton, the artist's wife, in her posthumously published book *A Hunting Alphabet: the ABC of Drag Hunting*. In my variant, "A" stands for Aly Akavan, to whom thanks are offered for photographs and books that had once belonged to Newton and were found at his Box Farm by its new owner; and for Averill Geus, whose numerous clippings from *The East Hampton Star* were a fount of information.

Heartfelt thanks to all who joined the hunt, each of whom, whatever their position in my alphabet, were equally indispensable: Richard Barons of the Southampton Historical Museum; Bob Curran, Jr., of The Jockey Club; Courtney T. Burns, Chief Curator of the New York State Military Museum in Saratoga Springs; Diana Dayton, formerly of the East Hampton Library; Ann Morgan Dodge and Patricia A. Sirois of Brown University's John Hay Library; the writer Gary Dycus; Eva Greguski of The Long Island Museum of American Art, History and Carriages; Helen Harrison of the Pollock-Krasner House and Study Center; Sona Johnston of the Baltimore Museum of Art; and Dorothy King of the

Pennypacker Long Island Collection at the East Hampton Library. Under the letter "L" a cluster of thanks is called for, not only to the noted dancer Murray Louis and his equally distinguished colleague Alwin Nikolais, who together rescued more than 25 canvases from Newton's youth that they found in the 1950s in the process of converting the artist's old Southampton studio into their residence; but to Art Liese of the Sporting Gallery and Book Shop. Rounding off the alphabet, my thanks also to Joan Stahl at the Smithsonian American Art Museum; Turner Reuter at the Red Fox Fine Art Gallery; and Eric Robinson at the New-York Historical Society. Finally, but by no means least, I wish to thank Peter Winants for some very fruitful conversations and suggestions.

Special recognition is due the collectors of Richard Newton's paintings, who always exercised great forbearance in responding to my sometimes perhaps importunate questions: D. Frederick Baker; Bruce E. Balding; former MFH John J. Carle; MFH and Mrs. Farnham Collins; Mr. and Mrs. D. Weston Darby; Mrs. William D. Doeller; former MFH Mrs. John B. Hannum, Jr.; The Jockey Club; Mrs. Helen T. Johnson; the Knickerbocker Club; Mrs. Gladys M. Leake; the Long Island Museum of Art; Mrs. Susan Louderback; Murray Louis; Dr. and Mrs. Edward Mahoney; Marion Maggiolo; Mrs. James McCormick; the Middleburg Community Center; Dr. and Mrs. William Mimms; the Museum of Hounds and Hunting; the Parrish Art Museum's Katherine Crum and Chris McNamara; Robert Pell-Dechame and Mrs. Stephanie Pell Dechame; Mr. and Mrs. Stuart Quillman; Mr. and Mrs. Leonard Shoemaker; Mrs. William S. Stokes III; Mr. and Mrs. Oakleigh Thorne; MFH Martha D. Wadsworth and MFH W. Austin Wadsworth. And last of all, but really first, my thanks go out to Mr. and Mrs. W. Bell Watkins, who loaned the Museum of Hounds and Hunting Mr. Newton's decorative four-panel room screen, the painting that got this merry chase started.

Every project has its top-tier contributors. I would like to extend special thanks to the "author's circle": Bruce E. Balding, the catalyst of this book, whose company paid for its publication; Nicholas Prychodko, the omnipresent editor-in-chief; and, for his aesthetic taste and clarity of vision, Charles Sheblom, the designer. My wife, Patricia A. Daly, my inspiration and loving companion, provided parallel thinking or criticism as needed.

# Foreword

Painters are not always cast in the role of starving artist. Richard Newton, Jr., certainly was not. A gentleman of independent means, he was a full-fledged member of the social set he so ably portrayed as a painter and often led in the chase as a master of foxhounds. Both pursuits require patience and creativity, and entail a judicious combination of excitement and refinement. It takes time and dedication, and skill honed by practice, to train horses and hounds and to purposefully build up layers of paint; the payoff is an exhilaration that is produced not only by the end result—a finished work of art or a hunt well run—but by the process of getting there.

The Atlantic shore of New York's Long Island may have exercised the earliest and most profound influence on Richard Newton's development as a painter. Struggling to capture his seaside experiences on canvas, the young man was forced to confront the subtle effects of diurnal and seasonal changes in lighting on the color and texture of water, surf, sand and vegetation, on display in the environs of his family home in East Hampton. By 1891, at age 17, Newton was already sending his oils and watercolors, with titles evocative of the region's attractions, to shows in Boston, New York and Chicago.

Simultaneously, the budding artist began developing his prowess as a horseman. No mere poseur, he not only assumed the sartorial attributes of a foxhunter but rode to the hounds as only the young can— with carefree abandon. An inkling of what it was that so captivated Newton about foxhunting on Long Island, in a more gracious era when it was pursued by ladies and gentlemen of means and leisure over open terrain as yet unspoiled by suburban sprawl, is offered in a standard reference of that time: "A better *riding* country it would be hard to find; the big upstanding post-and-rail fences meet one every few hundred yards, hounds run fast over the flat grass country and it requires a bold, big-jumping, cleanbred horse to live with the Suffolk" (Higginson and Chamberlain, 1908: 171).

Dividing his time between the easel and the chase—indeed, combining the two pursuits, which became his lifelong pattern—carried dual rewards. By 1902, Richard Newton had been elected the first master of the Suffolk Hounds. And in his seaside studio, at his parents' home on the dunes overlooking the Atlantic, he perfected his painter's craft.

While Newton's early work was painted directly from nature and captured the ever-changing qualities of the seaside, he was also fascinated by rich narrative illustration, such as that of Howard Pyle and

N. C. Wyeth. In his life's work as a painter primarily of outdoor portraits and sporting scenes, he was able to strike a compromise of sorts, portraying his subjects, human and animal, in all the chromatic glory of their natural environment. This fusion is his trademark. His equestrian portraits are known for their precision and correctness, as well as for the richness of their backgrounds. There are those, certainly, that would cavil about the formulaic or static nature of his work, the presentation of subjects in predictable poses, the repetitive use of motifs and models—in a word, that it carries the fatal "genre" label. But could that not be said of any work of art that conforms to the expectations of its audience and the conventions of its era?

Newton, after all, was commissioned by wealthy society figures to portray them in the hunt field, whether jumping fences or displaying their prize horses or hounds in their home territory or stable yard. His portraits of horses are bold, accurate and realistic, with the human figures no less sharply and colorfully rendered. Newton's is an apt formalism, perfectly designed for describing the social ritual of foxhunting, with its panoply of customs, etiquette and costume imported from England. In his adherence to the established norms of sporting art, Newton placed himself squarely in the tradition set by his predecessors, but he brought to it his own unique attributes, notably a level of technical accomplishment and a sensitivity to the natural environment equaled by few of his peers. The backgrounds of his portraits and his narrative scenes are often less rigidly representational, painted in an impressionistic style with broader, flowing brushstrokes evocative of the spirit of the bucolic landscapes presented, different in approach but perfectly compatible with the almost photographic depiction of his patrons and their mounts. There may be discerned in aspects of Newton's landscapes, particularly in his rendition of trees, a brooding, elemental quality that is sometimes fraught with a subliminal significance arguably reminiscent in its effect—for all their differences—of the work of N. C. Wyeth.

Especially in juxtaposition with Newton's immaculately tailored human subjects and well-groomed horses, this aura of something older and more mysterious than the superimposed figures is suggestive of the processes of change even then underway throughout the traditional hunt territory in the eastern United States that served as his inspiration. Soon the centripetal forces of population growth and technological innovation would consume and irrevocably transform the countryside, subjecting it to the tyranny of modern civilization, and replacing woods and open fields with housing developments and shopping malls. It is an irony of history that, by helping make those areas where they chose to pursue their sport fashionable—attracting the upwardly and outwardly mobile as well as those who would cater

to their needs—it was the foxhunting class that planted the seeds of its demise across much of its historic domain.

While his human subjects commissioned paintings, horses, captured in every conceivable form, whether in high spirit or in repose, were Newton's delight: flying over fences, pulling elegant carriages and humbler coaches, or even a farmer's plow; quietly gazing out of their barn's half-door into the stable yard; bathed in yellow lantern-light in the stable, or grazing lazily in the summer sun. No detail was spared his exacting attention. One need only look closely at one of Newton's grey horses or carefully examine a scarlet hunt coat, to realize that it contains nearly as many variations in tone and is as finely modulated as a cloudy sky, a flowing creek or the speckled coat of a foxhound. Light, wispy brush strokes, bold blotches and seemingly meaningless touches of the brush conspire to capture the moment, evoking gentle breezes, birdsong and the baying of hounds, and the variegated fragrances of a brisk fall morning in the field. There is a remarkable evenness to Newton's craft over time. It would not be appropriate to apply such terms as "late," "early," "middle" or "in-the-manner-of" to Newton's oeuvre. His consistency was a result of the achievement of technical mastery at an early age and a lifetime spent practicing it. Each sitting, to be sure, brought the artist new challenges, but they appeared to be confined to portraying the peculiar features of a particular human subject, horse or hound. Once these were faithfully rendered, the rest of the painting simply, so it would seem, fell into place.

This book most certainly did not simply fall into place for the author, but required a considerable amount of time and effort and assiduous detective work. Newton's creations and the facts of his life, unfortunately, have not been spared the ravages of time and neglect: much has been lost, destroyed or forgotten. Herewith, John Head splices together the fragmentary evidence of the life and times of Richard Newton, Jr., and presents all the equestrian portraits and sporting art produced by the artist between 1906 and 1945 that he had managed to locate as of the publication of this volume. It is the first to be devoted to the life and work of this significant early-20th-century American society painter and sportsman, perhaps the only individual to have been simultaneously a master of foxhounds as well as of sporting art.

<div align="center">

George A. "Frolic" Weymouth

and

Nicholas Prychodko

</div>

Dedicated to Patti

# "Well Known in Foxhunting Circles"

A measure of the fullness of Richard Newton's life as an artist, gentleman and MFH was recorded by *The New York Times* after his death on April 19, 1951, at age 77. His obituary included mention of his activities as a clubman who had belonged to the Brook Club, the Southampton Beach Club, the Turf and Field Club, the United Hunts of America, the National Hunt and Steeplechase Association, and the Masters of Foxhounds Association. It also noted that he had served "as a well-respected judge for horse shows in both England and America." But his true significance then, as now, was unequivocal: "He was well known in foxhunting circles both in this country and in England, and had achieved some note as an artist of hunting scenes and horses, as well as for his portraits."

While to have "achieved some note" as measured by the *Times* is no minor accomplishment, today Richard Newton, Jr., has been largely forgotten. However, even though the artist's sketchbooks and personal papers have disappeared, many of his sporting oil portraits still reside quietly in prominent equestrian households, having been passed down from one generation to the next.

Newton's portrait of John R. Townsend, master of the Orange County Hunt, which he painted in 1906, signaled a departure from the seascapes that had heretofore characterized his creative efforts, and it is his earliest known artistic foray into the world of foxhunting. This was a social milieu with which he was intimately familiar. Himself master of the Suffolk Hunt and an accomplished equestrian, when Richard Newton, Jr., turned his attention to documenting American foxhunting, it was as a peer among his patrons.

Tall and lanky "Dicky" Newton, "old 'Collars and Cuffs,' as he was affectionately known"— according to one of the last members of the Riding Club in East Hampton, Mr. Ken Skenck, who

The emblem of Richard Newton's Southampton Hounds, embossed on the brass buttons worn by members of the hunt.

11

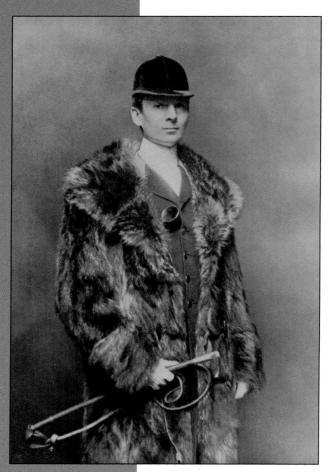

*Richard Newton, Jr, MFH Suffolk Hounds, c. 1907. Photo in Higginson and Chamberlain, The Hunts of the United States and Canada.*

was over 90 years old when he was interviewed by Mrs. Averill Geus for *The Maidstone Club, 1941-1991, The Second Fifty Years*, and whose mother, Mrs. Hallie Skenck, had hunted with Mr. Newton —played a seminal role in bringing the hunt to the Hamptons. In this endeavor, as noted in *Baily's Hunting Directory*, he had the assistance of Martin J. Aylward, his huntsman from 1908 to 1940, and his whippers-in, Edward Simmons and Thomas (or James) Murphy. (Mr. Murphy's Christian name is given as "Thomas" by Baily's, and as "James" in an inscription on a photograph taken in 1946 of Newton's 1924 portrait of Murphy.) The introduction of foxhunting, dramatically blazoned by the Suffolk's scarlet coats with mauve collars and brass buttons, brought with it a vast array of social activity to the East End of Long Island. "Big Hunt Supper and Smoker," runs the headline of the October 25, 1903, *East Hampton Star*, announcing one such highlight of the social season. "Richard Newton, Jr., is arranging for a hunt supper and smoker to be given at Water Mill on Saturday evening.... The Essex hounds will meet at Southampton at three o'clock...after which a buffet supper will be given on the lawn. All owners of land over which the hounds have hunted this season are invited to attend. It is Mr. Newton's intention to give a personal invitation to every such land owner, but should he omit any one he wishes it understood that all are invited. Mrs. T. E. Babcock is to be the caterer, and she has orders to prepare suppers for 300. The success of the hunt supper given at the same place last fall...will tend to largely increase the attendance this year."

Richard Newton put a great deal of effort into his social life, but he worked at least as hard at improving his foxhounds

*John R. Townsend, MFH, Riding Greek Dollar, 1906. Oil on canvas, 43 ¾″ x 54 ½″. The Long Island Museum of American Art, History and Carriages, Stony Brook, NY. Gift of Mrs. J.V.S. Bloodgood, 1964.*

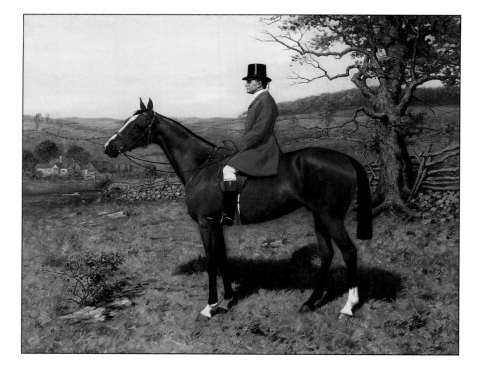

and perfecting his painting style and technique. By September 1919, when *Country Life* magazine published *The Grey Hunt Team—Suffolk Hounds*, with the more evocative title *In the Glade,* its editor was able to report that "Mr. Newton is at his best depicting hunting scenes. Here he has caught most cleverly the feeling of sun-shot coolness of a clear September morning."

*Marsh and Mere*, 1893.
Oil on canvas, 16˝x30˝.
The Parrish Art Museum,
Littlejohn Collection,
Southampton, NY.

"'Be not afraid; I was
your father's friend,
And will be yours, if
you are worthy him.'"
An illustration for
*Christalan*, c. 1903.

# In Two Worlds—Town and Country

A scion of a family comfortably rooted in the upper middle class, Richard Newton, Jr., was born in New York City in 1874. Mary Eliza Lewis Newton, his mother, was the daughter of Elizabeth Harley and Charles S. Lewis, president of America's oldest bank, the Bank of North America, Philadelphia. His father, Reverend Dr. Richard Heber Newton (1840-1914), was for thirty years rector of All Angels Protestant Episcopal Church, NY. In a privately printed tribute to their elder brother Francis following his death, Richard and his younger brother F. Maurice were to describe their antecedents as "exemplars of moral, intellectual and social integrity." Reminiscing about their early years, they wrote that their father, a "scholarly preacher, author and civic reformer," created "a home where the bringing up was less by dictum than by the pervading and compelling influence of high thought and pure spirit. The intellectual friends who constantly gathered at our father's table left impressions of delight and invigoration…."

The lively city life experienced by the young boy in Victorian New York was tempered by frequent escapes to the relatively tranquil countryside. His family was counted among the pioneers from Manhattan at the seaside colony of East Hampton, having arrived there in 1879, when Newton was a boy of five. These idyllic childhood years were later recorded by F. Maurice Newton in an article titled "First Home on Dunes Built by Rev. R. H. Newton," which appeared in *The East Hampton Star* on October 24, 1935. Maurice reminds readers that the trip from New York to East Hampton was "a tedious journey in those early days," four hours by train to Bridgehampton and the rest of the way by stage, "a plodding deliberate process in a time that musicians would call 'largo.'"

The Newtons' summer cottage on the dunes was built in the spring of 1888 "on the furthest point towards the west between the ocean and Georgica Pond. Four acres at $300 an acre.... Because he was a minister, my father was joked about disregarding the Bible's discouragement against building on the sands.... In the Fall of '88 or '89, a storm of unprecedented fury slashed and battered the coasts of New York and New Jersey. I remember my father's anxiety that night, and his going out frequently with a lantern to see what margin of safety was left."

Their cottage, sturdily built, survived this and no doubt other Atlantic squalls. To enhance their camp the Newtons later bought Briar Patch, a cottage across Georgica Pond built after their dune house on property that they had sold to the artist Robert V. V. Sewell, who went off to live and paint in Morocco. Enlargements and improvements to it were made in 1904. Maurice's article records that "the original studio room" overlooking the sea "was kept and used by my brother Richard, and a new and larger study and library was built to which my father moved some 4,000 volumes, at that time retiring from active ministry and giving up his New York City home." Among R. Heber Newton's various pursuits in retirement, of particular interest is his role in organizing the 1912 "East Hampton for the 'Bull Moose' campaign." His friend Theodore Roosevelt was said to be "delighted by this political success of a clergyman." The Long Island painter Albert Herter, recalling a visit to the Newtons' summer home, wrote that "there were no cocktails, no bridge, no all-night parties. We were happy painting in the stable and at night thinking up practical jokes on the Robert Sewells, who lived in a small cottage in the woods."

The specific details of Richard Newton's formal education and artistic training are unknown, although his family obviously valued education. Heber Newton was the author of a number of published essays and at least two dozen books. It is also known that Richard's older brother Francis, born in 1872, studied architecture at Columbia and painting at the Art Students League, and trained at the Delaware studio of Howard Pyle and at the Colarosi Atelier in Paris. Both boys were exposed to the growing number of Long Island painters who were working with their neighbors Thomas Moran and William Merritt Chase, as well as to the busy art scene in New York.

Richard seems to have used a paintbrush to great purpose from an early age. Records show that in 1891, at age 17, he exhibited *Even Song* at the National Academy of Design in New York; *Two White Swans All White as Snow* at the Annual Exhibition of the Art Institute of Chicago; and *Children of Atlantis* and *Waiting* at the spring exhibition of the Boston Society of Watercolor

Painters at the Boston Art Club, which at the time still relied on gas lamps for illumination. When the 19-year-old artist exhibited *Italian Slaves* at the Boston Art Club in 1893, Boston Electric Light had just introduced incandescent lights to the club's new Romanesque building on the southwest corner of Dartmouth and Newbury Streets, where in 1895 he also exhibited *Spring Idyll*. The annual exhibitions directory of the National Academy of Design in New York lists the following Newton titles: *Even Song*, 1891; *Voice from the Sea*, 1893; *At Sunset* and *Harvest Moon*, 1895; *Old Moorish Bridge on the Way to Tetuan, Morocco*, 1900; and *Late November in New Jersey*, 1901. Prices for the paintings, when listed, range from $200 to $500.

In 1893 Richard and Francis spent several months in Tangier, Morocco, as houseguests of the artist R. V. V. Sewell, their former neighbor and family friend who had recently left East Hampton. *Marsh and Mere* (page 14), now in the Parrish Art Museum, dates from this year.

As a 21-year-old of some private means, Richard Newton purchased a house in 1893 near the St. James Hotel in Water Mill, Long Island. There he became a leading member of the local hunt club and helped to establish its kennels—thereby reinforcing the inextricable bond between his personae as painter, foxhunter and socialite. It was further strengthened in 1902 when he founded the Suffolk Hounds, serving as its master of foxhounds until the hunt disbanded in 1942. Francis Newton, as Suffolk's fieldmaster, led the bold riders in the "first flight"; and his home, Fulling Mill Farm, was a hotbed of social activity well known for hunt breakfasts with "Maryland flair," thanks to his Baltimore-bred wife, the former Amy James. Accounts of hunt society events, including mention of the Newtons' participation, frequently appeared in *The East Hampton Star*.

Newton's early oils of landscapes and seascapes were very likely painted from life as he observed it in rural Long Island. The natural scenes he selected were probably begun on site and later finished from memory in the studio. Like most open-air painters he was interested in the ever-changing coastal weather and light. While many of these paintings remain undiscovered, those that have surfaced share a common long horizontal format of 16″ x 30″. Six, however, in a departure from the norm, are elaborate paintings with a medieval theme, featuring multi-turreted castles, knights in armor, battle-ready horses, damsels and life at court, which were created for Katrina Trask's book of poems *Christalan*, a tale of a "knightly lad" seeking to be both "Valiant and True." Mrs. Trask and her husband, Spencer, were the founders in 1900 of Yaddo, a writer's

retreat in Saratoga, NY. Once again, young Richard Newton can be found very much at ease in one of the more prominent social circles of his day.

Concurrently with his first exhibitions in the last decade of the 19th century, and well before he launched his career as a painter of sporting scenes and portraits, Newton was also working hard at riding to hounds. He was later to outline his early happy days as a young foxhunter in an article, "Meadowbrook Hounds First to Hunt in The Hamptons" (*The East Hampton Star*, October 24, 1935). For two seasons in the early 1890's, he notes, the Meadowbrook Hounds—Newton and others at the time seem to have preferred this variant to the more familiar "Meadow Brook"—hunted foxes and jackrabbits around Southampton. The sport continued its development in the area when P. F. Collier brought his private pack of English foxhounds, the Monmouth County Hounds, from New Jersey. After three years Collier retired to Newport and "transferred his rights to Mr. Newton, who has held the county ever since." Newton's article proceeds to document a seminal moment in Long Island hunt history, when "the Essex Hounds from Gladstone, N.J., came down here as the guests of Francis and Richard Newton jr., and were kenneled at the old Corwin Farm in East Hampton, with the hunt servants and the horses. The farm is now owned by Mr. and Mrs. Francis Newton. The hounds were hunted by Richard Newton jr., as acting Master…. This was done for seven years." The hounds then went back to Gladstone, and "the Suffolk Hounds were formed, with Mr. Newton elected Master; this was in 1902." Later, he "brought back a pack of English foxhounds bought in England, on the *Olympic*. He exercised these hounds twice daily on the upper deck and the day after their arrival they ran a drag at Southampton as well as if they were still in England."

The modern reader will no doubt find it of interest that Newton's 1935 article contained mention of the fact that for "the past two seasons Mrs. John Vernon Bouvier III has acted as junior fieldmaster" of the Suffolk Hunt. Later the wife of Hugh Auchincloss, she was to gain wider recognition as the mother of Jacqueline Kennedy Onassis, an avid equestrian in her own right.

The Suffolk's hunting territory, as recorded with the Masters of Foxhounds Association after its recognition of the pack in 1908, was described in *Baily's Hunting Directory* as "a fast galloping country over grass—all post and rails—some 40 miles long and about 5 miles wide from Shinnecock Inlet in the west to Montauk Point in the east." For the next 40 seasons, until the hunt was disbanded in 1942, Richard Newton, Jr., served as master of this picturesque foxhunting paradise along the Atlantic.

Over the years, many colorful descriptions of hunts and hunters appeared in the local press and diary entries. *The East Hampton Star* on September 13, 1901, reported on a meet with Essex when Newton, as master, cast his hounds from the town green at the Liberty pole in East Hampton. "The scent was taken on Egypt lane, and the hounds shot off through the fields…. It was a pretty sight to see the horses leap so gracefully over the fences, and the hundreds of people who had driven to the top of the hill on Further lane enjoyed the spectacle. Frank Newton, who is an excellent rider, was unfortunate in having an unruly horse, and as he was taking one of the fences, the animal tripped and threw Mr. Newton over his head, rendering him unconscious."

A few years later, on September 9, 1904, the *Star* described another meet, as exciting and well attended, if apparently less eventful. The Essex Hounds, with Richard Newton, Jr., as acting master, gathered on the village green, where "the start was observed by a large number of spectators from our summer colony and townspeople. Members of the Riding Club and their friends on horseback, in carriages and automobiles followed on the highways…, several times getting a fine view of hounds and riders as they took the fences and galloped across the fields."

A brief humorous tribute to Newton's imposing presence and dedication to the hunt is included in a very long poem, "A Drag with the Old Essex," composed after the retirement of Charles Pfizer, MFH, and dedicated to him "and all the members of the Essex Hunt who rode so gallantly in the Old Drag": "Dick Newton, the painter, distinguished and tall, It will be a blank day if he misses a fall." (By Somerset, privately printed in 1928 in New York and quoted by J. Blan Van Urk, in *The Story of American Foxhunting: From Challenge to Full Cry, 1865-1906, Vol. II:* 303-306.) And in an Essex Hunt diary entry from December 11, 1901, the future master of the Suffolk Hunt is portrayed in characteristic form: "Mr. Richard Newton, Jr., followed on the road on a black pony and had in leash a terrier, *Mary O'Jane*, which made a very sporty picture" (Ibid: 300).

The Hamptons, like other rural playgrounds of the affluent during the early 20th century, enjoyed a lively equestrian scene. The automobile had yet to eclipse the horse, and hunt club and driving activities always included families whose names were to be found in the *Social Register of New York*. Prominent among them were the Newtons and many who served as subjects of Richard Newton's portraits, as well as the Thomas B. Clarkes, whose daughter would soon become Mrs. Richard Newton, Jr.

Grace Clarke Newton was one of four daughters of the well-regarded New York art collector Thomas B. Clarke (1848-1931) and the former Fanny Eugenia Morris. The couple, married on November 14, 1871, also had one son. Mrs. Clarke, as reported in the papers of the day, was from a distinguished and well-to-do family. Having achieved early business success, from 1869 onward Mr. Clarke bought and sold art of the Hudson River School. In one of his more notable sales, in1899, Mr. Clarke sold $235,000 worth of paintings and Chinese porcelains at auction. In a 1924 sale a collection of his furniture and antiques was recorded at $103,679.

Certain aspects of Miss Grace Clarke's life can be surmised from her family's listing in the 1897 *Social Register of New York*, which includes their residence at 22 E. 35th St. and membership in the Union League and the New York Yacht, Brooklyn, and New York Athletic clubs. Letters were to be sent care of her parents, to the Metropolitan Club. That year, Grace privately printed *A Book of Rhymes*, dedicated "To My Father." Also listed in the 1897 *Social Register* is Richard Newton's sister, Mrs. William Welles Bosworth (née Elizabeth Lewis Newton) of 142 E. 33rd St.

An intense—albeit short-lived—romantic interlude preceding Grace Clarke's involvement with Richard Newton is suggestive of a passionate and perhaps somewhat impulsive nature. According to reports in the press at the time (preserved in the archives of the Social Register Association), Harry Wakefield Bates, a socially prominent Bostonian, met Miss Clarke while they were both guests on board the yacht of Edwin Gould, where "he is said to have fallen madly in love" with her. He "urged his suit with ardor and soon had Miss Clarke's promise to be his wife." They eloped, and were secretly married in New York on June 19, 1900, before departing for a wedding trip on the groom's yacht, the *Gleam*. "Their happiness lasted until they paid a visit to New York. Then something happened, just what, few know, and the bride took herself off to her old home at East Hampton…." In August, she "was taken ill with what appeared to be nervous prostration. Following this illness there were rumors that she had commenced proceedings to have her marriage annulled." These proved to be correct.

The Clarkes' East Hampton home, The Lanterns, decorated with ship's lanterns from around the world, was often mentioned in the local papers as a gathering place for hunt breakfasts and teas. In the midst of this lively society by the sea and in the city, whose purview encompassed both fine art and horses, Richard Newton courted Grace Clarke Bates.

*The East Hampton Star*, on October 9, 1903, published news of one such event that the young couple might have attended, a "paper chase," that is, a simulated hunt game originating in the early 1850's in England, in which a rider or two play the part of the quarry and, after being given a short lead, are swiftly pursued, in hopes of capture, by a group of fellow sports. In America, in the later 1870's, paper chase hunts were held in the fashionable seaside region of Far Rockaway in Queens County and in the Genesee Valley, where even Major W. Austin Wadsworth, the organizer and longtime master of the Genesee Valley Hunt, who was to sit for a portrait by Richard Newton, once played the "hare."

Declared by the *Star* to be "a great success," it started on a "perfect and glorious autumn day …from the crossroads in front of the Sea View House, Amagansett, at 3:30 o'clock. Mr. Ives and Master Marshall acted as the hares. They had a start of about ten minutes and were finally caught after an hour's chase through the fields, bushes and woods. About twenty riders participated in the chase and several followed in carriages. Mrs. Thomas Clarke entertained the party at her cottage, The Lanterns, after the chase."

Mrs. Newton's father was reported to be a "clerk of the course" for another gathering of the East End's "horsy set," the Maidstone Club's second annual gymkhana or outdoor show, which was featured in *The East Hampton Star* on August 5, 1904. His son, Thomas B. Clarke, Jr., and four other young men rode in this season's new and certainly very comical "doll perambulator race," whose rules stated that "each contestant was to ride with small doll in hand, throw doll over a fence to nurse," one of five small girls, "who must place doll in perambulator, and return with it to starting point." No doubt it was, as the article went on to say, "exciting and amusing, particularly the nurses' part of it."

Richard Newton, Jr., won the steeplechase after he "came through the field" on the home stretch "and took the lead which he held to the finish." On this "perfect" day "almost the entire summer population of East Hampton," as well as "many from Southampton and other near by places" had assembled around "the big oblong square enclosed for the races." On one side, it was "completely lined with carriages and their occupants, while the other side was taken up with hundreds of chairs which were all filled with spectators," and completing the encirclement was "the paddock at one end and the meadow and pond at the other." Picture another event that day in which "each pretty contestant drove a goose in harnesses," and the innocent fun of a potato race,

a "mannikin" [sic] race, an egg race (with 22 riders entered) and a shirt race, as well as booths with refreshments, a wheel of fortune and a Punch and Judy show. In the shirt race, six riders, each of whom had brought a lady assigned the task of sewing buttons on his shirt, dashed from the far end of the course to where the seamstresses were stationed, brought their steeds to a quick stop, put on their shirts, and galloped back to the post. "Adding to the picturesqueness of the scene" were two young ladies selling programs, one costumed as a flower girl and the other as a Valkyrie, and "little Miss Dorothy Ives," who "rode a donkey about the grounds and dispensed peanuts."

Diverting as such pastimes no doubt were both for participants and for spectators, they could not compare with the thrill of the chase. Vivid scenes of the Suffolk Hunt and of MFH Richard Newton's role in these events during the first decade of the 20th century were recorded by Lida L. Fleitmann (Mrs. J. Van S. Bloodgood) in her memoir, *Hoofs in the Distance* (1953). Particularly memorable is the description by this future MFH of the Smithtown Hunt of her debut as a fox-hunter.

"In the fitful glare of a bonfire kindled on the shore to keep us warm while waiting," she recalls, "I saw my first pack of foxhounds, their black and tan faces and waving sterns framed in the open door of the old Sag Harbor boat.…They were the Suffolk hounds brought over from New York.…The gangway of the ferry put down, the hounds surged ashore and through woods that a few hours earlier in the sunshine had been gold and crimson, but now stretched out dark and unfriendly, we started on the long trek back to the kennels at Watermill. Ahead rode Dick Newton, the Master, his tall lean figure barely visible in the dim light from a crescent moon, with the hounds behind, padding silently in the sandy road, keen to riot after hours of confinement, and kept in order by an odd trio of whippers-in: Murphy, myself on my plunging black mare, and Henry Russell mounted on his smart chestnut *Mr. Jorrocks*.

"…On that memorable first day of hunting, wishing to be something 'slap,' but not quite venturing to try my ex-racehorse in the lead of a sporting tandem, I sent *Judge* on ahead with a groom and drove myself out with the hackney tandem; as I passed my 'hunter' on the road I felt that he looked quite as smart as *Jorrocks*, with his mane neatly braided, and wearing a big ringed snaffle with red rubber hand pieces. Arriving at Bridgehampton I found Dick with his hounds and two whippers-in…already gathered on the green in front of the white clap-boarded Presbyterian Church. Standing somewhat apart was Grace Newton who, in spite of her timidity, felt it her

*Coaching Scene.*
Oil on canvas. Photograph
among Lida. F. Bloodgood
papers, National Sporting
Library, Middleburg, VA.
Location unknown.

bounden duty as the Master's wife to make an appearance on a little piebald pony; once hounds moved off she trotted valiantly along until we threw in, and then withdrew."

Qualities of Richard Newton's character that may have contributed to his effectiveness as a master of foxhounds are dramatically illuminated by Mrs. Bloodgood. "This mild-mannered man, a sporting artist of renown, not only possessed a violent temper—I have seen him calmly dismount and single-handed thrash a burly farmer who had strung wire across the line—but also the courage of a lion. According to legend, after lying three days and nights with his horse at the bottom of an abandoned well into which they had fallen, he appeared at a dance a few hours later without even commenting on what he termed a trifling accident; on an other occasion, breaking his leg at night on an icy street, he dragged himself home and did not call a doctor or even rouse his household until morning so as not to disturb their sleep."

Included in *Hoofs in the Distance* is a caricature of Richard Newton, MFH, by Vincent Handley. Tall, sporty yet natty, his full figure is depicted in profile, deliberately elongated to emphasize his stature. Both artists are mentioned on the book's dedication page, where the author pays tribute to "the memory of Richard Newton and Vincent Handley, whose sketches and water-colors made in an old guest-book appear in these pages."

Mrs. Bloodgood had good reason to be grateful to Richard Newton. Brilliant on the race track though it may have been, her horse, Judge, was not cut of the special cloth required for a field-hunter. "That I survived one fence, let alone a whole season's hunting, can only be attributed to the Special Providence watching over drunks and fools," she observes. "Dick Newton had how-ever, sufficient reason to curse me; I jumped in his pocket, crossed in front of people, and entire-

*Lida L. Fleitmann, Riding Gypsie Queen.* Oil on canvas. Only a 6 ⅛″ x 8 ⅛″ fragment—of the horse's head and neck—survives. It is preserved, along with a photograph of the entire painting, among the Lida F. Bloodgood papers at the National Sporting Library, Middleburg, VA.

ly unable to hold my pulling mount, hustled hounds and committed every crime except ride over them. Ignorant though I still was of hunting etiquette, my instinctive love of animals and dislike of seeing hounds cringe away from horse's hoofs, caused me of my own accord to ride somewhat to the side of the line.

"At the end of the season, Dick, counting up the number of fences I had reduced to kindling wood, decided that something must be done about me, and since my mother, who careened along the roads following the hunt in her phaeton, was blissfully unaware that anything was wrong with my mount, Dick sent an SOS to Johnnie [Townsend], then in the Adirondacks curing his hay fever at Paul Smith's: 'Find that girl a decent horse or she'll break her d—n neck.'

"Thus," declares Mrs. Bloodgood, "*Gypsie* came into my life." Among her papers in the National Sporting Library, Middleburg, VA, there is a small scrap of canvas annotated by her on the frout. That tiny fragment of an oil painting, along with a vintage photograph, is all that remains of Newton's undated portrait of *Lida L. Fleitmann, Riding Gypsie Queen.*

Many years after the events she recorded, while living in Rome, and perhaps under the spell of the Eternal City, Mrs. Bloodgood was inspired to immortalize with pen and ink her horses and the Suffolk Hounds. Alone among Richard Newton's subjects, she contrived to express in words what he captured for future generations with brush and oils.

It was in this happy and inspiriting milieu that Richard's older brother Francis, on October 10, 1904, married Amy James, one of twelve children of Henry James and the former Amelia Belknap of Baltimore. Prior to her marriage, Amy often came to East Hampton to visit her brother Henry at his home on the dunes, which was later purchased by Juan Trippe, the founder of Pan American Airways. Later that winter, on January 9, 1905, Richard married Grace Clarke Bates. Subsequent editions of the *Social Register*, from 1906 to 1915, list Mr. and Mrs. Richard Newton, Jr., as residing with her parents at 22 E. 35th St. in New York.

A more intimate glimpse into Newton family events is provided in an article by F. Maurice Newton, Richard's younger brother, in the October 24, 1935, issue of *The East Hampton Star*. "At

the end of 1913, my mother passed on," he recalled, "and a year later, unable to stand the loss, my father, at the age of 74." *The New York Times* on Sunday, December 20, 1914, reported the death of Rev. Newton under the headline "Noted Divine, Dead," followed by the declaration in boldface, "His Opinions Criticised —Resigned in 1902, After Being Charged by Church with Entertaining 'Liberal Religious Views.'" The New York Public Library catalog lists 24 books authored by Rev. Newton, including such broad-reaching titles as *The New Thought of Immortality*; *The Present Aspect of the Labor Program*; *The Right and Wrong Uses of the Bible*; *Womanhood: Lectures on a Woman's Work in the World*; *The Mysticism of Music*; *Christian Science: The Truths of Spiritual Healing and Their Contribution to the Growth of Orthodoxy* and *Parsifal: An Ethical and Spiritual Interpretation*. "A Service to Honor the Memory of Rev. Heber Newton" was held on February 7, 1915, at the Church of the Ascension, located on Fifth Avenue and 10th Street in New York. Among those listed as attending, in addition to the distinguished clergy named on the program's cover, were Hon. Theodore Roosevelt, Hon. Joseph H. Choate, George Foster Peabody and George Haven Putnam.

Shortly after the death of his parents, the seemingly magical existence shared by Richard and Grace Newton in their ten years of married life came to an end. On October 15, 1915, *The New York Times* reported the untimely death, at home, of Grace Newton. The newspaper listed the funeral service as private and noted that the couple did not have any children.

In keeping with its weekly schedule, *The East Hampton Star* published news of the event on October 22, 1915: "After a lingering illness of several months duration, Mrs. Grace Clarke Newton, wife of Richard Newton of this place and New York, died at the Biltmore, New York, Friday morning last. Mrs. Newton was the only daughter of Mr. and Mrs. Thomas B. Clarke, with whom she and Mr. Newton had made their home for several years. The deceased was a woman of fine character and her sweet and gracious manner and unfailing courtesy endeared her to all with whom she came in contact, and she will be greatly missed here where she had many friends. Beside her husband and parents, Mrs. Newton is survived by one brother, Thomas B. Clarke, Jr., of New York."

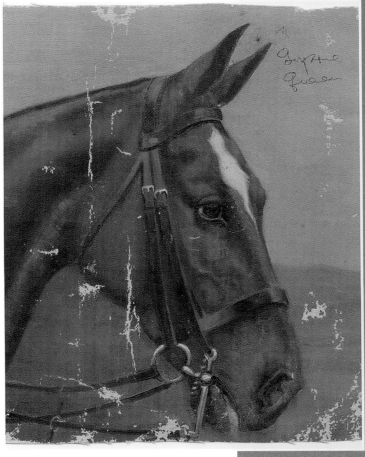

Surviving fragment of *Lida L. Fleitmann, Riding Gypsie Queen.*

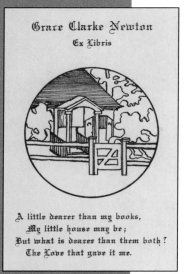

With Grace's death the Clarkes had witnessed the passing of all four of their daughters, each as a young woman. Five years later, on November 20, 1920, her mother, Fanny, died. Thomas Benedict Clarke's obituary, following his death at age 83, appeared on January 18, 1931. Reported to be a founder and governor of The Brook, a member of the board of governors of the Century and Union League clubs and a member of the Manhattan, Metropolitan, New York Athletic, New York Yacht, Suffolk Hunt and Sleepy Hollow clubs, he was survived by his son, Thomas B. Clarke, Jr., a sister and a brother.

Immediately following the death of his wife, during what was no doubt a difficult period devoted to reflection, Richard Newton edited and arranged for publication Grace's literary efforts. The result was *Poems in Passing*, a leather-bound limited edition printed in 1916 by the De Vinne Press and published by E. P. Dutton & Company. The poems are very self-revealing and provide important insight into the Newtons' marriage. In his "Introductory Note" to the volume, Richard sheds some light on its preparation, indicating that some of the poems "had been approved and corrected by the Author for publication; others were still unfinished; but many have been brought to light from obscure places, such as private letters, fly-leaves of books, the backs of pictures, old diaries, and other remote sources which might easily have eluded discovery. Moreover, the poems

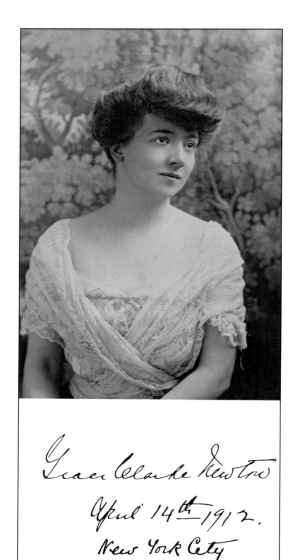

here given comprise less than half the material at hand; but much of the rest is of a nature so intimately personal that it must remain locked forever in the hearts of those to whom it was written."

On the opening page of *Poems in Passing* is a sepia-toned photographic portrait of Grace Clarke Newton. She is wearing a white off-the-shoulder beaded dress. Under the picture is a handwritten inscription, "Grace Clarke Newton, April 14th 1912. New York City." The handwriting is Richard Newton's.

Among the personally revealing material in the book is the poem "The Tryst," dedicated "To My Valentine—R. N., Jr."

WHEN the Sun dips down
    To the world's bright rim,
Listen, Eyes of Brown,
    Summer 's there for him!

And it 's there for You
    When your eyelids close.
—Skies of turquoise blue
    And the budding rose.

On the other side
    Of just one small world
Will you choose to ride,
    If the sails are furled?

There is many a way
    Out of snow and mire.
Close your eyes and say,
    "To My Heart's Desire!"

*Canter far and free,*
    *Gallop fast and fleet.*
*'Neath the dreamland tree*
    *We shall meet, my Sweet!*

"Aftermath: On the Heights Above 'Msallah" is another verse celebrating the couple's love for one another. Labeled a "Soprano Solo," it is the last of several poems included in "One Night in Tangier: A Song Cycle," which the author had evidently intended to make "a semi-dramatic whole with scenic directions and music complete, so that it could be presented on the stage." Opposite the poem is the book's only other photograph, apart from the frontispiece. Captioned "Grace Clarke Newton at the 'Castillo de la Cabaña,' Havana, Cuba, March, 1915," it shows Grace, her face averted from the photographer, gazing out across the rampart towards the sea. In her left hand she holds a bouquet of wildflowers. When he took the picture Richard could never have guessed that eight months hence, in the autumn of 1915, he would be mourning Grace and creating a book in her memory.

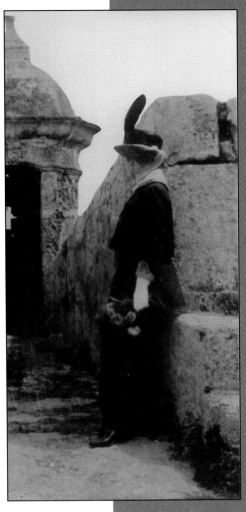

Grace Clarke Newton at the 'Castillo de la Cabaña,' Havana, Cuba, March, 1915. (From *Poems in Passing*, opposite page 94.)

Tipped into each copy of *Poems in Passing* is an original bookplate, identified by the editor as "Grace Clarke Newton's Book-plate, Shewing the entrance of her house at Easthampton, L.I." The plate is a line drawing of the front door of the Newtons' home. A verse she composed and pasted in her library books is printed below the drawing.

Another poem, "Who Burns the Bridge," has special significance for the couple, as revealed in a note from the editor: "Lines on a Roman bridge now in use and partly restored by the Moors in Morocco, on the way to Tetuan. Written for the book-plate of R. N., Jr." Not surprisingly, this lovely old bridge was also the subject of a Newton painting shown in 1900 at the National Academy of Design in New York. It is uncertain if the couple had traveled to Morocco together or if it was the painting that inspired the poem.

> WHO burns the bridge whereon he crossed
>     To kneel at Wisdom's altar,
> Shall reach her shrine, tho' tempest-tossed.
> —Who burns it not may falter.

The finishing touches to Richard Newton's record of his wife's verses were included in a chapter in *Poems* titled "Occasional Stanzas: Written in Books, on the Reverse of Pictures, Etc." The first poem, "A Line to Live By," found by him "on a blank page in the Poems of Elizabeth Barrett Browning," is presented on two pages, first reproduced as it had been written by hand in pen and ink, and on the opposite page set in type. It must have been a moving discovery for Mr. Newton, as the poem was signed with the initials G.C.N. and dated April 14, 1912, New York City, the very same day that the portrait of Grace opposite the title page was taken. The poem's first line is, "Keep thou the poet's heart!"

"In Lighter Vein" is the title Newton gives to the second-to-last chapter. If he had not been aware of it previously, he must have been pleased to find "The Song of the Hunter." The first stanza clearly reveals the source of its author's inspiration in the couple's common enthusiasm for equestrian sports.

> OH! why should anyone desire
>     To wear a coat of black
> (Or any kind of mufti) and
>     To ride a gentle hack?
> Yes, even to motor to a meet
>     Is not the way to ride!
> When hounds are cast upon the green
>     It is a "good-un's" pride
> To push his gallant bay or grey
>     Well up into the race,
> And take four feet of timber sound
>     At steeplechasing pace.

"In Lighter Vein" also contains the poem "Any Husband to Any Wife," whose second and final stanzas suggest that the couple differed as to residential preference.

> It is not that I love you less,
>   Or that I wish to roam;
> But all the instincts I repress
> Turn city-ward, and you confess
>   You love our country home.

It is Grace Newton's voice that speaks through *Poems in Passing*, but the hand of her loving husband and editor is always evident. On the last page of the little book dedicated to the memory of his departed wife, he records the details of its printing:

> *And here ends this first volume of*
> POEMS IN PASSING *by Grace Clarke Newton, of which 152 copies only have been printed by The De Vinne Press, New York, on hand-made paper, and the type distributed, in this year of our Lord one thousand nine hundred and sixteen.*

Richard Newton also edited another volume, *A Small Girl's Stories*, as a tribute to his wife. This book, which was also printed by The De Vinne Press and published by E. P. Dutton & Company in 1916, contains Grace Clarke's juvenilia. Six copies were produced and distributed to family members. In the preface, Mr. Newton notes that it comprises "some of the many stories which were written by Grace Clarke Newton, when she was Grace Clarke, a small girl of eleven years of age," and which she called the "Rose Series." So faded by time that "it has been a labor of love to make many of them out," they were "found where they were long ago forgotten by the author, who never even told the one who in after years was so close to her, of their existence." He "longs to look back to those happy years of hers and see the beautiful child playing with her dolls and writing fairy stories for them, as well as poetry." Because she would not have wished these early stories to be found, much less published, "only a few copies have been printed for her family alone, who will guard them sacredly, thus honoring themselves in honoring her first baby writings, which foreshadowed the after flowering of the perfect Rose."

Still very hard at work on his memorial, Richard Newton had in 1916 "in preparation" two other manuscripts of his wife's writing, tentatively titled *A Hunting Alphabet* and *Poems in Passing— A Second Gleaning*. The former title was published, with the sub-title *The ABC of Drag Hunting*, by

E. P. Dutton & Company, New York, in 1917. A copy for sale on the Internet was recently described as a "set of 26 amusing hunting quatrains, and especially noteworthy for Newton's illustrations of hunting scenes, including portraits of notables of the Essex, Orange County, Meadow Brook, Geneseo [sic], Suffolk and Millbrook Hunts….First Edition, one of 262 copies.… With ten illustrations after paintings by Richard Newton, Jr. Full turquoise morocco, panelled spine, gilt inner dentelles, cream silk end papers, … a fine copy in felt-lined board slip case."

The "G" page of the alphabet is illustrated with a portrait Mr. Newton painted in 1911, *J.E. Davis, Esq., MFH—Meadowbook Hunt* (page 40). Mrs. Newton's poem on the opposite page humorously captures a social aspect of the day's sport.

<div align="center">

G

G is the Gathering Gloom of Her Grace,

The Great One, invited to open our Ball

When she heard that the Master had had a bad fall

And the Honorable Whip is to fill in his place.

</div>

*Poems in Passing—A Second Gleaning*, the intended fourth volume of Mrs. Newton's writing, was never published. The original manuscripts of the published books and of this last work in progress have not been found.

# Inspiration from Life:
## Sporting Scenes and Portraits 1906 - 1940

The year 1906 marks a thematic shift in Richard Newton's painting from seascapes to sporting art. Somewhat surprisingly, given his love of foxhunting, Newton's first known sporting work is not of hounds working the country, but a commissioned portrait of *John R. Townsend, MFH, Orange County Hounds*, now in the collection of the Long Island Museum of Art, History and Carriages. For the next 35 years, documentary equestrian portraits, hunting episodes and stable scenes were the hallmarks of his career as an artist.

Perhaps as part of the same 1906 commission, according to Mackay-Smith's epic text, *The American Foxhound*, the artist painted two foxhound portraits, *Orange County Ranta* (page 31) and *Orange County Stafford '99* (page 32). These paintings were owned by Mr. and Mrs. Robert Livingston Gerry, who, before their wedding in 1908, also sat for portraits by Mr. Newton—Mr. Gerry in 1906 (page 36), and Mrs. Gerry, as Miss Cornelia Harriman, in 1907 (page 35). During this productive period, the 32-year-old Newton also created a large group portrait, *The Orange County Hunt* (page 32), which depicts Robert L. Gerry, Peter G. Gerry, J. R. Townsend, MFH, E. H. Harriman, and Robert Goelet (l-r), each mounted on his favorite hunter, with a full pack of hounds rounding out the scene. It is fortunate that the OCH group portrait was photographed by A. F. Bradley, since the canvas was destroyed in a 1968 fire at the clubhouse in Plains, VA.

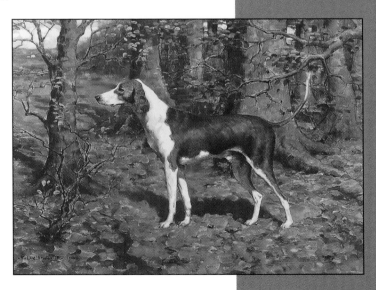

The only photographic portrait of Richard Newton, Jr., located to date (page 12) appeared in *The Hunts of the United States and Canada* (1908), by A. H. Higginson and J. I. Chamberlain, along with an account of the artist's own hunt, the

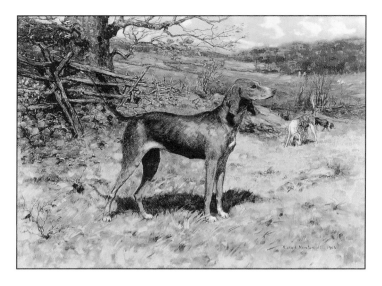

Suffolk Hounds, whose territory was Long Island's famous East End.

During his tenure as master of the Suffolk Hounds, Newton often traveled to paint commissioned portraits of his fellow masters. Such a relationship between patron and artist, as peers not only socially but in terms of avocation, is somewhat unusual—much more so, an MFH who is also an accomplished painter. Unfortunately, there are no records of Newton's 1908 painting and foxhunting trip to Warrenton, VA, where he created two individual portraits, *Mr. James K. Maddux, MFH, Riding Shining Light* and *Mrs. James K. Maddux, Riding Grey Cap*.

Years later, in an article that Newton wrote in 1935 about the history of his Suffolk Hunt, he

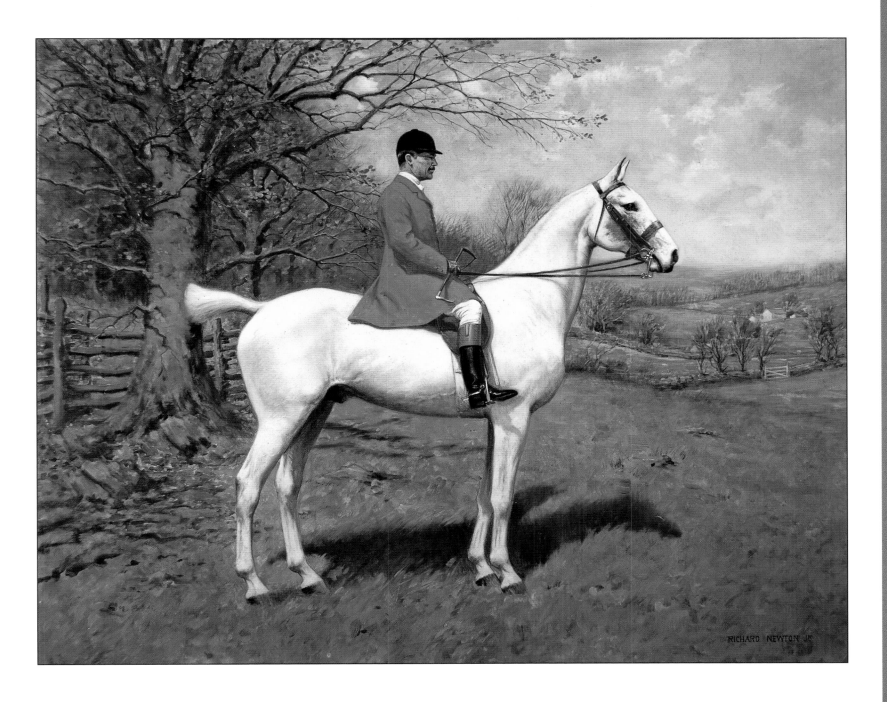

James K. Maddux, MFH,
Riding Shining Light,
1908. Oil on canvas,
40˝ x 50˝. The Museum
of Hounds and Hunting,
Leesburg, VA.

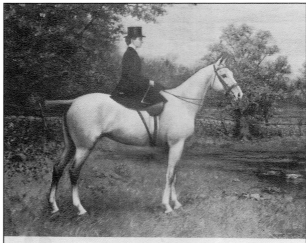

Richard Newton, Jr., 19th Century British. "Mrs. James K. Maddux on Grey Cap, Warrenton Hunt, signed and dated 1908. 40" x 50".

mentioned that at approximately this time he imported a pack of English foxhounds on the ocean liner *Olympic*, exercising them twice a day on deck to keep them fit. The day after their arrival in Long Island, "they ran a drag at Southampton as well as if they were still in England" (*East Hampton Star*, October 24, 1935). By 1910, a clubhouse was obtained and fashionably furnished, and a kennel built near Water Mill, NY.

*The Pups "Meet," Heyday House Terriers* (page 38) dates from this

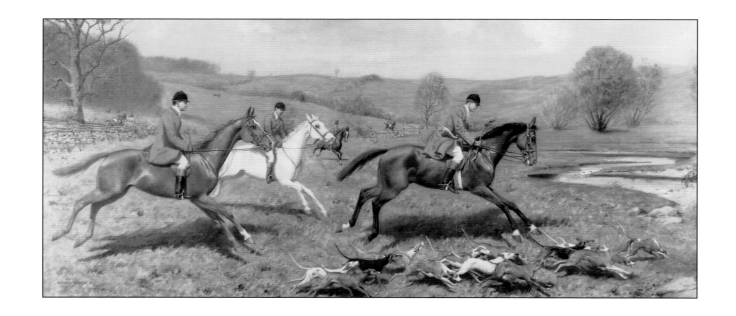

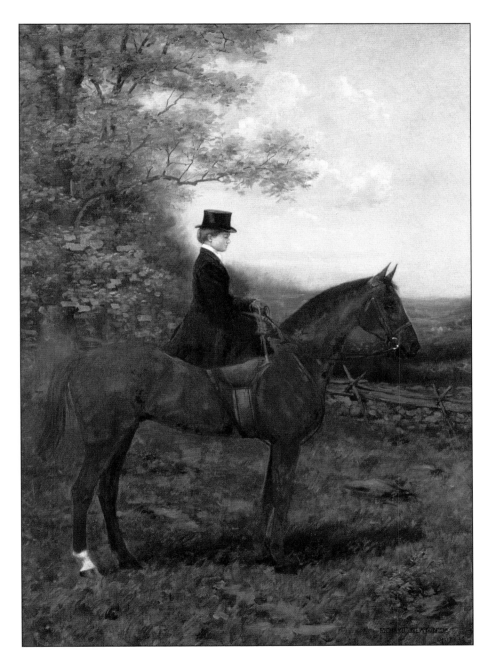

period. Painted in 1910 for MFH Joseph E. Davis, who himself would be the subject of a Newton portrait the following year, this is a canvas that utilizes the same long narrow format characteristic of the artist's boyhood seascapes. In the painting is a fictitious coat of arms, which includes a rabbit and a banner reading *Arrectus Auribus!* This phrase is thought to be part of a longer passage found in Virgil's *Aeneid* whose meaning may be roughly translated as "having perked up their ears," which is what rabbits must do when being pursued.

Another canvas that was probably painted around this time, although it is not dated, does not appear to have been commissioned. *Lifting the Pack to the Next Covert, No. 3*, (page 37) depicts mounted foxhunters and hounds emerging from a wooded glade. Orange and green highlights of fall foliage and undergrowth seem to glow in an atmospheric foreground where earth tones predominate under a lowering sky, in marked contrast to the bright pastel hues of rolling fields, sky and water in the distant background. Rendered in an impressionistic style reminiscent of Newton's earlier landscapes, its intent—rather than representational as in the portraits that now constituted the

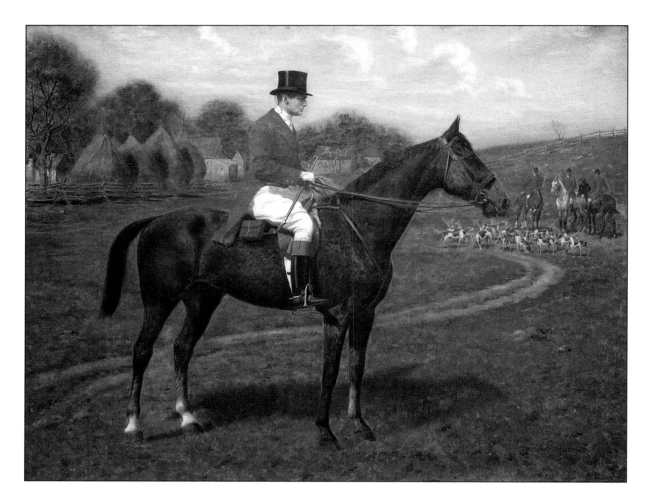

bulk of his output—is to convey a mood. Nevertheless, although hunters and hounds are handled in a somewhat cursory manner in keeping with the style, one cannot help but speculate that the central figure is intended to portray Richard Newton, Jr., MFH, himself, mounted on his gelding Tornado. Both horse and rider are consistent in every detail, down to Newton's distinctive mauve collar, with contemporary descriptions and the few surviving images of the artist and his steed.

A report in *The East Hampton Star* on July 21, 1911, headlined "Suffolk Hunt Club Opening," details the formal inauguration of its new quarters, situated in a century-old farmhouse near the

Hay Ground, and offers a glimpse into customs of the period. "The Suffolk Hounds of Southampton, Richard Newton, jr., master," it is observed, "have hitherto been kenneled in town, but the new site presents a better hunting country directly adjacent to the clubhouse and kennels." The occasion attracted "over one hundred of the members and their guests" for an "inspection of the house and grounds, followed by the serving of a light collation and the enjoyment of a special musical programme arranged for the occasion." A fraternal institution, "the Golf Club of Southampton helped do the honors, and out under the trees tea and other refreshments were served" while an orchestra played. The hunt club's "charter members and the organizing committee include many well-known New York society people and others prominent in the Long Island social colony." Among the long list of names of those present were van Rensselaers and a Pell, as well as Mrs. Oakleigh Thorne, whose husband would sit for a Newton portrait in 1917. Mr. and Mrs. Thomas B. Clarke, and MFH and Mrs. Richard Newton, Jr., round out the guest list.

Joseph E. Davis, MFH, Newton's fellow MFH and neighbor, was painted on his farm in Upper Brookville, NY, in 1911(page 40). Outfitted for a day's sport, Davis is shown with his legendary huntsman, one of the best of his time, Thomas B. Allison, and the staff and hounds from the Meadow Brook. Allison, who lived on the Davis estate, was brought to Long Island by Mr. Davis from Culpepper, VA. His whipper-in, James (or Thomas) Murphy, although absent from this painting, was the subject of a portrait by Newton in 1924 (page 60).

One of the leading blue-ribbon driving horses of the period, *Lady Dilham*, was also the subject of a Newton painting in 1911 (page 39). Now in a private collection in Wilmore, KY, the canvas

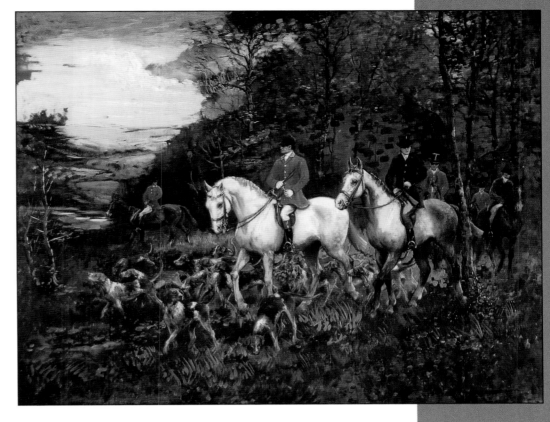

*Lifting the Pack to the Next Covert, No.3*, 1910. Oil on canvas, 38˝ x 28˝. Collection of Helen T. Johnson, Bristol, CT.

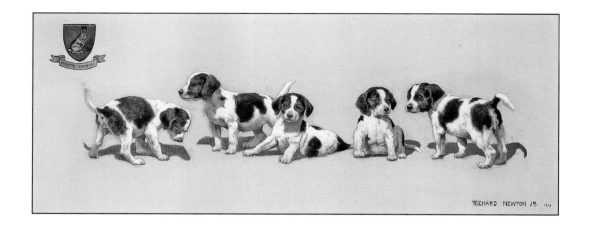

The Pups "Meet," Heyday
House Terriers, 1910.
Oil on canvas, 9˝ x 22˝.
Collection of Bruce E.
Balding, Litchfield, CT.

Dining room of
J. E. Davis, 17 E. 72nd St.,
New York, c. 1911.
His portrait by Richard
Newton, Jr., hangs above
the fireplace.

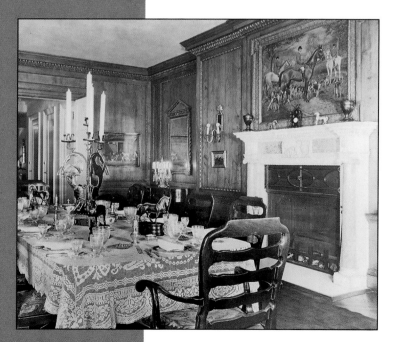

was bought at auction because the subject reminded the current owner of his son's horse. Owned and shown nationally by Miss Constance Vauclain, whose father owned the Baldwin Locomotive Works of Philadelphia, this remarkable mare once won as many as twenty-four blues in a single season at events such as Madison Square Garden and Devon—and caught the eye of Reginald C. Vanderbilt, who eventually bought her.

Another famous horse that served as a subject for Newton in 1911 was the stallion *Rock Sand* (page 43). The dark bay colt had already, in 1903, won the English triple crown, and now resided in America at the prestigious Nursery Stud owned by August Belmont, Jr. Frank Knight Sturgis, a broker of the firm Strong, Sturgis & Co., and president of the New York Stock Exchange between 1892 and 1894, presented the painting to the Jockey Club in New York, where it still resides. As vice-chairman and later chairman of the club, Mr. Sturgis also had his portrait painted by Newton. While the date of the sitting is unknown, the painting is listed in the artist's 1916 Ralston Gallery show in New York.

Not surprisingly, two of Newton's prominent portrait subjects and their horses were mentioned in an article about the "Hunt Club Show" that appeared in *The East Hampton Star* on August 15, 1913. "The second entertainment of the Suffolk Hunt Club which was held on Saturday last was the biggest thing of the kind ever held on the east end," it reported. Among "the official awards at the hunter show,"

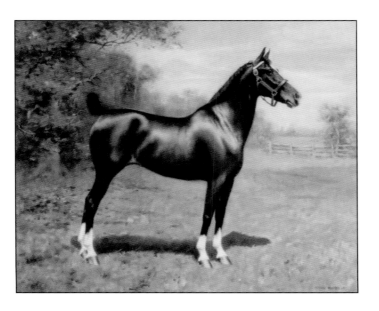

two went to subjects of Newton portraits. In the Lightweight Hunters class, J. E. Davis' Impulse placed second and Miss Helen Buchanan's Katydid (page 44) was pinned third. Newton had painted MFH Davis in 1911, and in 1917 would portray Miss Buchanan after she married and became Mrs. Helen Buchanan Jones. The paper further reports that a Davis gelding, Way Side, took the blue ribbon in the Middleweight Hunters division, while his horse Impulse was fourth among Saddle Hacks over 12 hands. Two other entries from the J. E. Davis stables, Sir Gile and Golden, also placed in their two classes. Mr. Newton was himself awarded first place in the Heavyweight Hunters class when he appeared on his white gelding, Tornado.

Newton took his painting supplies and hunting kit on two journeys in 1914. The first was to the hunt country north of New York City around Mt. Kisco, NY, to create the portrait of *Dr. Howard Collins, Riding Brisk* (page 41). He also visited Geneseo, in the western part of the state, where he painted *Catherine Louise Littauer, Riding Shawinigan* (page 42).

Not long after these excursions, *The New York Times*, in a brief article titled "Sporting Portraits on View" that appeared on April 13, 1915, announced the opening of an exhibition of Mr. Newton's work at the Ralston Galleries. "Twelve pictures are shown," it reported, "nine of which are portraits of American sportsmen and sports women in hunting costume."

In 1915, the Newtons, like many of the day's leading equestrians, also traveled to Cuba, where racing in tropical splendor was being widely promoted. A photograph of Grace taken in March 1915 at the Castillo de la Cabaña in Havana (page 27) records a moment from that sunny spring, one that seven months hence would become a memory never to be repeated.

*Lady Dilham*, 1911. Oil on canvas, 28˝ x 38˝. Collection of Dr. William R. Mimms, Wilmore, KY.

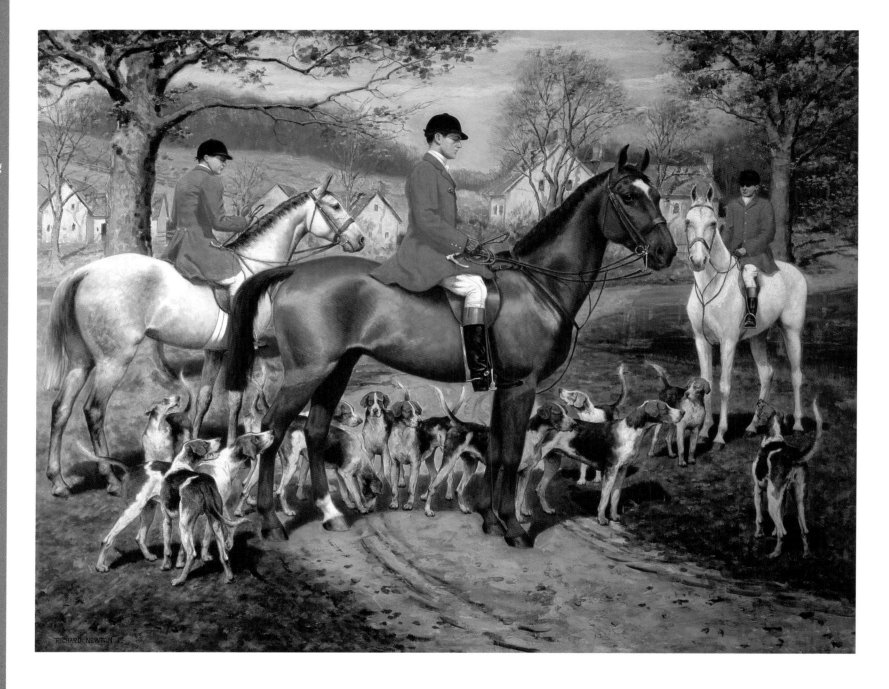

*Joseph E. Davis, MFH,*
1911. Oil on canvas,
40˝ x 50˝. Collection of
Bruce E. Balding,
Litchfield, CT.
Reproduced in *A Hunting
Alphabet: The ABC of Drag
Hunting,* by Grace Clarke
Newton, 1917; and in
*Country Life,* September
1919.

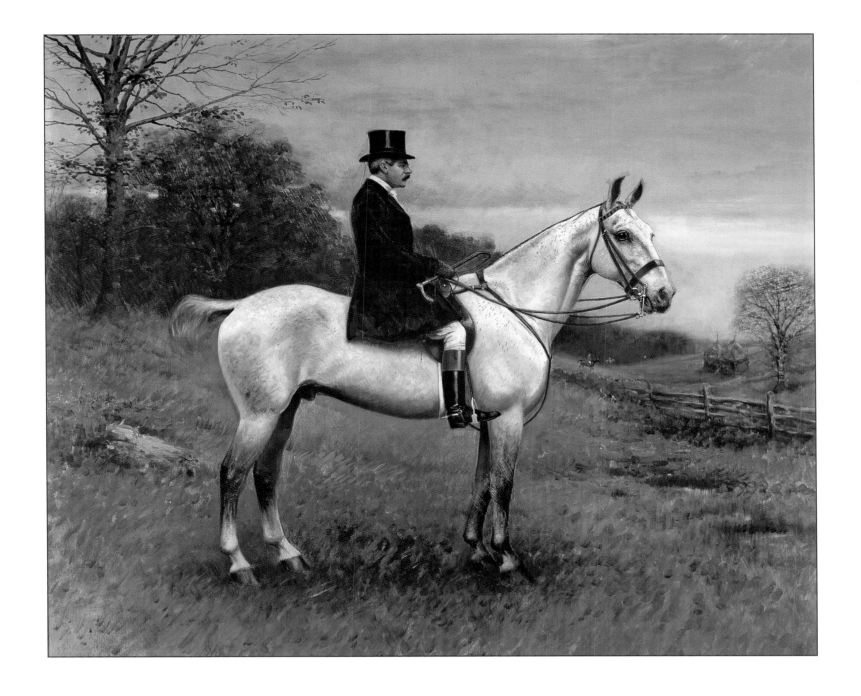

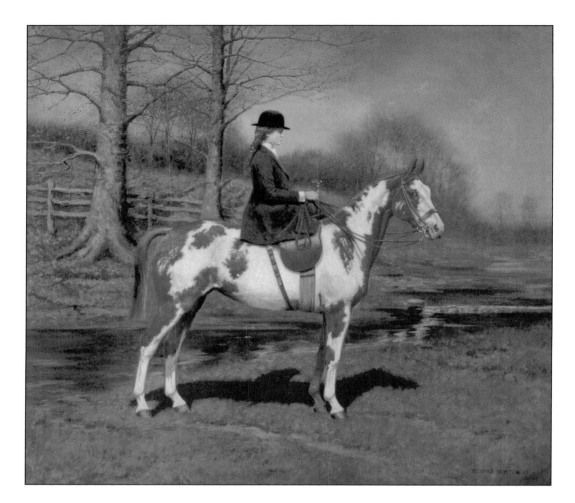

In the fall of 1915 Newton traveled once again to the hunting mecca of Geneseo, NY, to create two portraits, of *Major W. A. Wadsworth, Riding Devilkin,* (page 47) and his young son and only child, *William P. Wadsworth, Riding a Hinny with a Lone Hound* (page 45). Both portraits are in the Wadsworth Homestead collection and currently are on loan to the Museum of Hounds and Hunting.

No records of this hunting sojourn have been found. Lost are details of dinner parties, as well as the artist's preliminary sketches and working photographs. It is known that a Pullman train from

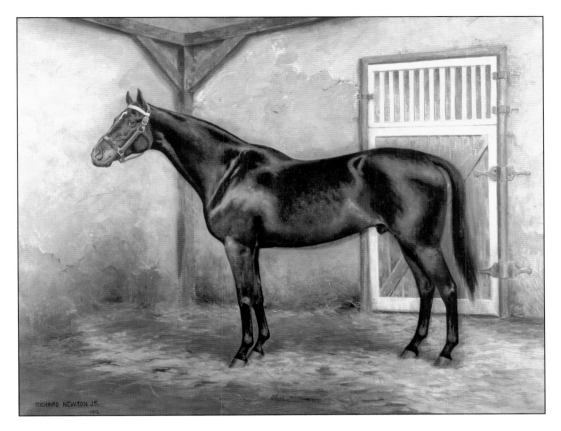

*Rock Sand*, 1911. Oil on canvas. 26˝ x 35˝. Collection of The Jockey Club, New York. (Presented to The Jockey Club June 1916 by F. K. Sturgis.)

New York frequently brought foxhunters to the village. Newton's canvases and brushes were probably on board in the fall of 1915, and perhaps those of his artist brother Francis as well, who was known to have hunted in "the Valley." The time required to create two oil portraits must have allowed for pleasant diversions in some of the best foxhunting country of the period.

The portraits he produced here demonstrate Newton's first-hand knowledge of horses and hounds in the accuracy of anatomy and pose he achieves. His brushes record a hound's conformation, and a horse's glistening tack and gentle eye. It seems that the formula for an equestrian portrait had not changed much since the 16th century. This is underlined by the artist's deployment of a "generic" hound, which appears in the painting of W. P. Wadsworth and again in the portrait of his father, Major W. A. Wadsworth. That is not too surprising, as it could well have represented the

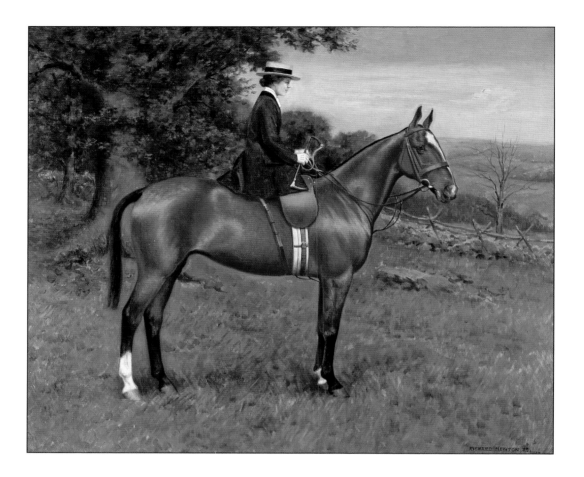

same individual; but an identical hound is also to be found in the 1911 painting of
J. E. Davis. These three hounds are exact replicas, matched in marking, pose and
gesture—seen from behind, tail up, neck curved, gazing upward directly at the sitter—and leading
the viewer to the most significant aspect of the painting, the portrait's human subject (page 42).
This all-purpose hound must have been in the artist's sketchbook or photographic file to be used
repeatedly, a subject prepared in proper pose, and ready for deployment as needed.

Newton hit a very impressive creative stride in his early forties. In addition to editing and pub-
lishing the three-volume memorial tribute to his wife, Grace, he also produced, in 1916 and 1917,

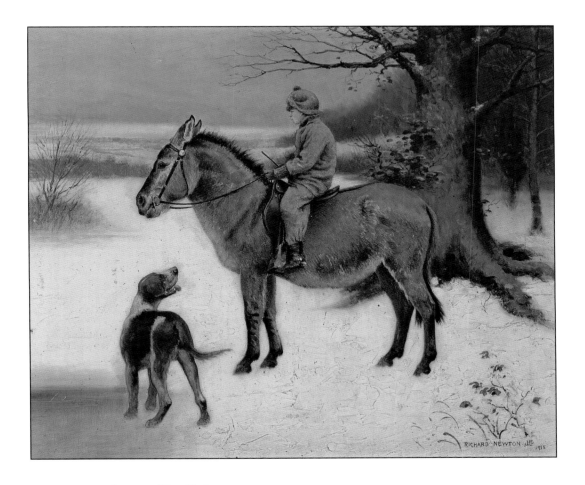

William P. Wadsworth,
*Riding a Hinny with
a Lone Hound*, 1915.
Oil on canvas, 20 ˝ x 24 ˝.
Collection of the
Wadsworth Homestead,
Geneseo, NY.

two one-man shows in New York.

An exhibition of paintings at the Ralston Galleries on Fifth Avenue was announced and reviewed in the April 17, 1916, issue of *American Art News*: "Of the school of Herring and Henry Stull, are the faithful and painter-like portraits of people on horseback, set in suitable landscape backgrounds, and stable scenes....There appear in scarlet and tops Major W. Austin Wadsworth, M.F.H., with his hounds; Robert Gilmore, Esq., at the Smithtown Hunt; Rufus C. Finch, Esq., M.F.H. of the Watchung Hunt; Howard Davidson, Esq., and Dr. Howard D. Collins of the Millbrook Hunt, as well as Misses Laura Harding, Dorothy Schieffelin...."

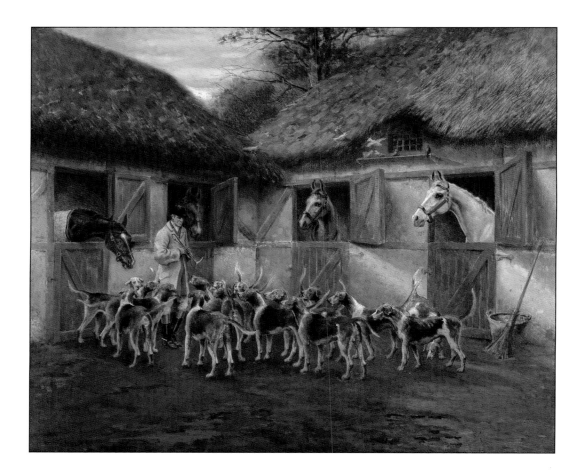

Also painted in 1916, an untitled early morning hunt stable scene, *Untitled (Hunter Barn)* may represent the artist's own Long Island kennels. Currently in a private collection in Middleburg, VA, it was received by the owner's family as a wedding gift from an English friend in 1939.

The following spring, Newton again showed at the Ralston. *The Rider and Driver,* a weekly magazine devoted to horses and their recently created competition, the automobile, on April 28, 1917, called the Ralston show "an interesting exhibition of paintings by that clever artist and good horseman, Richard Newton, Jr." To date, only one original painting from this exhibition of seventeen canvases, *Oakleigh Thorne, Esq. (MFH, Millbrook Harriers)* (page 50), has been located. "Among

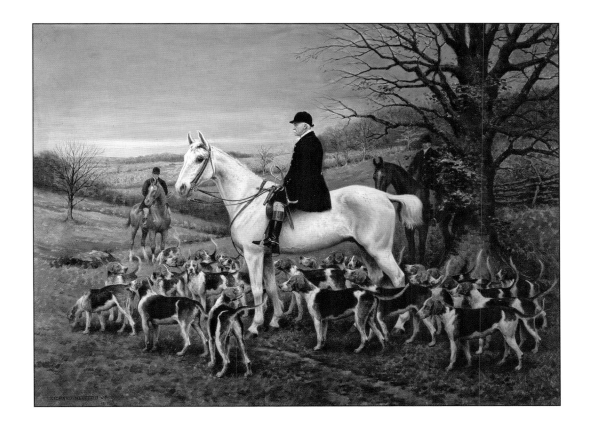

Major W. Austin Wadsworth, MFH, Riding Devilkin, 1915. Oil on canvas, 34˝ x 46˝. Collection of the Wadsworth Homestead, Geneseo, NY. Reproduced in *A Hunting Alphabet: The ABC of Drag Hunting*, by Grace Clarke Newton, 1917.

other examples, indicating a wide sweep of Mr. Newton's facile brush," the magazine cites the following paintings shown at the Ralston that remain unaccounted for:

*"Mrs. James A. Stillman; Mr. F. K. Sturgis; Mrs. Robert E. Tod—On 'Sceptre'; Master Stephen von Pfizenmeyer (with prize pom); The Adjutant of Squadron 'A'; John Tucker, Esq.—On 'Culvert'; Study for a Portrait—(Late afternoon sunight); Portrait of an Imported Thoroughbred Polo Pony—'Alfonso' (Alexander Smith Cochrane, Esq., owner); Lingering Light—Dunes towards Amagansett, L.I.;* and two canvases titled *Sunlight on the Porch—The Box, Hayground, L.I.; Cocker Spaniels of Mrs. Marcellus Hartley Dodge; Cub Hunting—Sunlight in the Woods—(Suffolk Hounds)."* The Adjutant of Squadron "A" is without doubt a portrait of Newton's brother-in-law, Thomas B. Clarke, Jr., who served in that capacity until his resignation shortly before his marriage to the popular actress and socialite

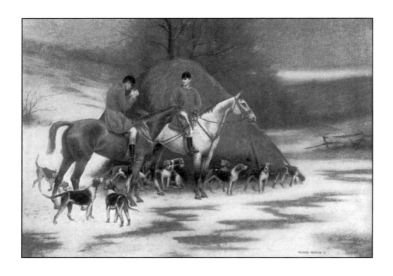

Elsie Ferguson. He is perhaps shown hunting or playing polo in uniform, a common practice of military gentlemen at the time.

Another group of Newton's sporting paintings that remain unaccounted for served as illustrations for Mrs. Newton's posthumously published *The ABC of Drag Hunting*. They include the portraits *Mrs. E. T. Cockcroft, Riding Danger* on the page illustrating the letter "A," and *Benjamin Nicoll, Esq.—Essex Hunt (on Cocktail)*, appearing opposite the rhyme for the letter "C," as well as *Drawn Blank, A Few of the Right Sort, The Grey Hunt Team—Suffolk Hounds* (page 13), and *A Hunting Morn*. A color reproduction of the latter work, which depicts a horse, was presented to Dr. H. Collins by Newton. An inscription below the image, apparently in the artist's handwriting, identifies it as a portrait of Foxy Quillet (page 51). On the back, Newton's dedication to Collins reads: "Dr. Howard D. Collins, 50 West 55th Street—From one who loves a gray to one who has a good one!"

In 1917, hunting was discontinued by the Suffolk Hounds as a consequence of the United States' formal entry into World War I on April 6 of that year. The clubhouse was bought and modified for family use by Mr. and Mrs. Thomas B. Clarke. The hounds were hunted from Aylward Farm and later moved to the newly established Southampton Riding and Hunt Club. That same year Newton made two painting trips to capture the likenesses of *Oakleigh Thorne, MFH,* (page 50) in

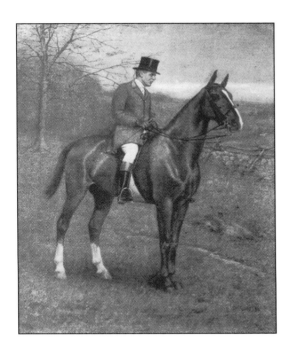

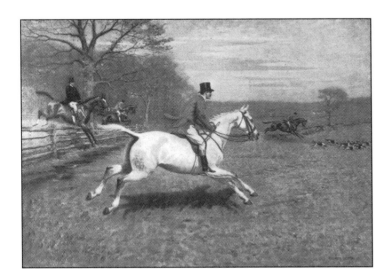

Millbrook, NY, and *Mrs. Helen Buchanan Jones Riding Katydid* (page 44) in Upperville, VA.

The August 17, 1918, issue of *The Rider and Driver* magazine carried a letter to the editor from Mr. Newton announcing the annual Suffolk Hunt Horse Show. That season's show, held in Southampton on Saturday afternoon, August 31, was "for the benefit of the Lafayette Memorial Fund for France's little orphan children."

Club records show that the Suffolk Hunt was placed in "reorganizational status" in 1918 and that hunting was discontinued from 1922 to 1925. The hiatus in the hunt club's activities may, at least in part, be explained by the romantic prelude to the marriage of Richard Newton, Jr., and Mildred Gautier Rice. Their wedding at St. Thomas' church in Manhattan on Tuesday, December 9, the Rev. Dr. Ernest M. Stires officiating, was "one of the largest in that church recently," according to a report appearing in The *East Hampton Star* on December 13, 1918. It "was followed by a reception in the Plaza Hotel, where Mr. Newton and his bride will live upon their return from their wedding trip, early in January." The ceremony was conducted before a chancel "made radiant with a decoration of pink chrysanthemums," the bride resplendent in "a costume of white satin trimmed with pearls and rhinestones and finished with a train of striped silver cloth and satin."

The bride must also have been an accomplished horsewoman. The front page of *The East Hampton Star* on Friday, September 5, 1919, listed Mrs. Richard Newton, Jr., among the "prize winners" who were presented with silver cups at the Suffolk Hunt Club's annual Horse Show held on Labor Day on the grounds of Mr. and Mrs. Frederick Ashton de Peyster in Water Mill. Neither "showers in the afternoon" nor "a mass of low hanging clouds during the show," prevented it from being "one of the most successful ever held, both by rea-

Benjamin Nicoll, Esq.— Essex Hunt (on Cocktail), before 1917. Oil on canvas. Reproduced in *A Hunting Alphabet: The ABC of Drag Hunting*, by Grace Clarke Newton, 1917. Location unknown.

*A Few of the Right Sort*, before 1917. Oil on canvas. Reproduced in *A Hunting Alphabet: The ABC of Drag Hunting*, by Grace Clarke Newton, 1917. Location unknown.

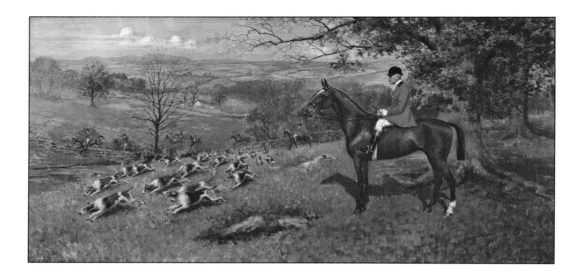

son of the number of entries and size and importance of the throng of spectators. Despite weather the women were arrayed attractively, and throughout the afternoon many of them watched the judging from the parking spaces and from the rail."

Now in his mid-forties, Mr. Newton, Master of the Suffolk Hounds, produced several sporting paintings during this period. A photograph of his 1918 portrait of *Master Luther Tucker* has been

preserved in the Smithsonian's Peter A. Juley & Son photographic collection. (The location of the painting is not known.) *The Grey Hunt Team—Suffolk Hounds* (page 13), created prior to 1917, was published as the September 1919 cover of *Country Life*. It was given a less specific, if perhaps more evocative, title: *In the Glade.* The canvas *Nala* (page 53), painted in 1919 in the English stable scene tradition, was recently bought at auction for a private collection in Milton, MA. *A Horse and a Terrier in a*

A Hunting Morn, before 1917. Oil on canvas. Reproduced in A Hunting Alphabet: The ABC of Drag Hunting, by Grace Clarke Newton, 1917; and as a photo-lithograph, hand-titled Foxy Quillet, 1948. Location unknown.

*Stable*, which portrays a grey hunter and a rough-coated pup standing in deep straw, was also created in 1919. The present location of the canvas, which was sold at a Sotheby's auction in 1990 by St. Hubert's Giralda, an animal welfare organization in Madison, NJ, founded by Geraldine Dodge in 1939, is not known. Recently added to the collection of the Museum of Hounds and Hunting, Leesburg, is Mr. Newton's 1920 *Portrait of a Racehorse and Jockey* (page 62). The Suffolk Hunt racecourse, overlooking the Atlantic, is visible in the upper left part of the painting.

Perhaps Mr. and Mrs. Newton traveled together in 1920 to Middleburg, Virginia, when the

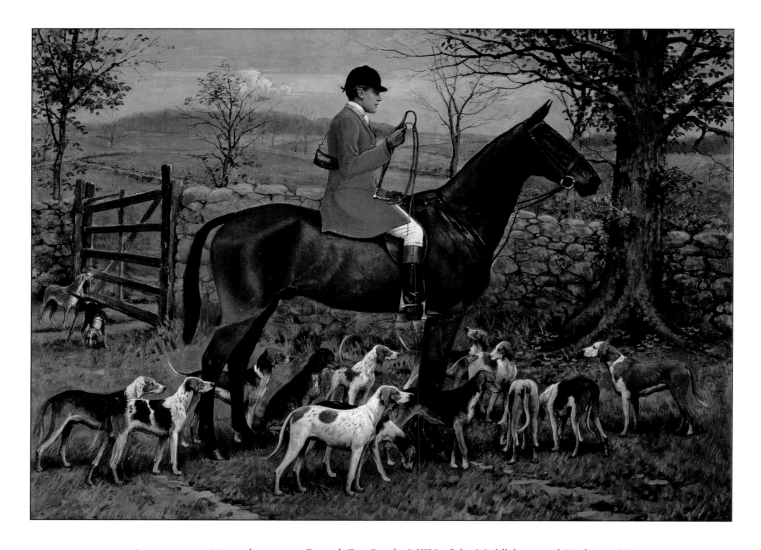

artist was commissioned to paint *Daniel Cox Sands, MFH of the Middleburg and Piedmont Hunt* (page 52). Mr. Sands, a former New Yorker, had in 1907 purchased an estate there, Benton, which served as a foxhunting venue for both packs and the scene of good sport and famous parties. Mrs. Sands was the former Edith Kennedy of Southampton, NY. The two couples may have been previously acquainted in Long Island.

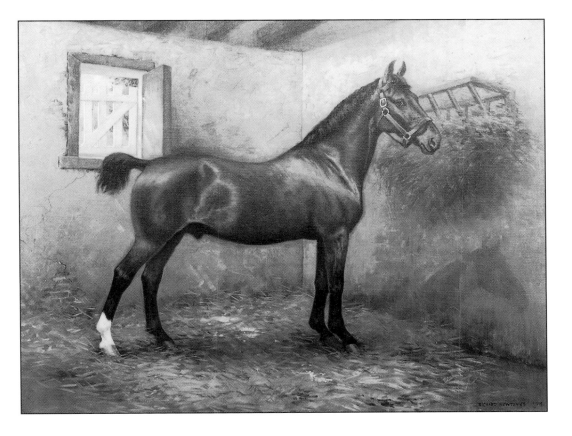

*Nala*, 1919.
Oil on canvas, 28˝ x 36˝.
Collection of
Dr. Edward Mahoney,
Milton, MA.

*Beagle Pack with Huntsman*. Oil on canvas.
Published on front cover
of *The Spur*,
September 1, 1926.
Location unknown.

Soon after this excursion, the Newtons' marriage was dissolved. No facts survive that might serve as a basis for even the most tenuous speculation regarding the events that led up to their divorce, which was recorded in Paris on October 9, 1922. "News of several divorce cases of prominent Americans became known here tonight," reported *The New York Times* by a special cable on October 12. Mrs. Newton's address was listed in the paper "as the Hotel Westminster, where it was said she left a month ago for America." Mr. Newton was reported as residing at "6 Rue Château La Garde, where it was said tonight that he was not at home." A mere four years after it began, the artist's second marriage ended. As in his first, there were no children. He was to remain a bachelor for the next ten years.

From this turbulent period in his personal life dates one of Newton's decorative four-panel room

screens, *Blue Ridge Hunt,* 1922 (page 56). With brush and bridle, the artist traveled for the third time to hunt country in Virginia. His commission there was to decorate Annefield, a lovely stone manor in Berryville. Its owner, W. Bell Watkins, asked the artist to depict his beloved new hunt territory. In fulfillment of this request, Newton painted a panoramic view of the surrounding countryside showing the field following hounds in full cry, and also captured a few hunting foibles: a riderless horse, some falls at fences, and a fox that neatly gets away.

In the artist's own hunt territory, the Newton family played an active role in organizing the Riding Club of East Hampton, which was founded in 1924 and opened in 1925. Richard Newton was credited in an *East Hampton Star* article dated September 9, 1927, with playing a seminal role in arousing interest in equestrian sports on the East End of Long Island, and his sister-in-law Mrs. Francis Newton was cited as a member of the "House Committee" responsible for furnishing the old farmhouse that served as the club's headquarters. The combination of its extensive facilities and the area's natural attractions made the club a lively seaside equestrian center in the Roaring Twenties.

During this relatively prosperous and carefree period in America between the Great War and the Great Depression, the era of speakeasies and flappers, not long before the Riding Club was formally established, Mr. Newton served as a judge at a horse show and paper chase held in the paddock overlooking Hook Pond on the estate of Frank B. Wiborg, soon to become the club's first president. "One of the gala events of the season," according to the September 7, 1923, edition of *The East Hampton Star,* "orange and blue banners floating in the breeze" contributed to the "beauty and gaiety" of the scene. There is probably a link between these colorful banners, presumably Mr. Wiborg's racing colors, and the silks of orange and blue that are worn by the unidentified jockey in Newton's *Portrait of a Racehorse and Jockey* (page 62). Mr. Wiborg's daughter, the legendary

*Over the Fence,* 1927. Oil on canvas, 24˝ x 72˝ room screen. Sold at Sotheby's, New York, June 4, 1993. Location unknown.

Sarah, married Gerald Murphy. Their lifestyle provided inspiration for their friends, the writer F. Scott Fitzgerald and his wife Zelda.

Two canvases are known to date from 1924. The first, identified in a catalog as *The Fox Hunt,* may have received this title, uncharacteristic of Newton, when it was last shown in 1994 at a Sotheby's auction. Its present location is not known.

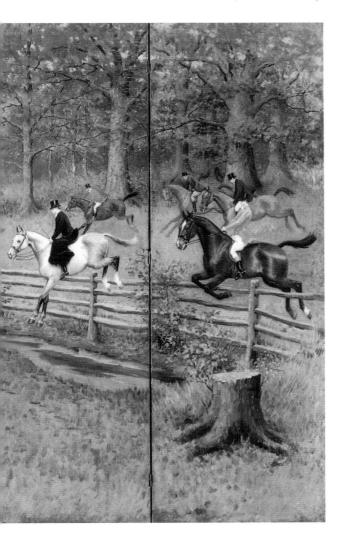

The second oil from 1924 is a portrait of *James Murphy, Whipper-in of the Suffolk Hounds* (page 60). A photograph made of the canvas in 1946 was found at the Frick Art Reference Library. The painting still resides in the Ticonderoga, NY, home of a descendant of its original owner, Col. Robert Means Thompson. His great-granddaughter Mrs. Robert Pell–deChame, who was three years old when she met Murphy and who now owns his portrait, recalls in a letter to the author that he, "in the parlance of 100 years ago, started off as a groom at Col. Thompson's estate at Southampton....Murphy had a thick Irish brogue, and was kind with a small child, and I loved him right off.... The fact that my great-grandfather...would have Murphy's portrait painted speaks for the esteem in which he held him—and the respect."

Two canvases created in a unique long rectangular format, perhaps for use over a mantelpiece, date from 1925: *Untitled (Early Morning Stable Scene)* (page 59) and *Untitled (Hunt Scene and a Farmer's Team)* (page 58). The paintings were acquired as a pair at an estate auction in Texas and are now in a private collection in Banner Elk, NC.

*The Spur* magazine featured one of Newton's paintings on the cover of its September 1, 1926, issue (page 53). A master of beagles and his pack are depicted hunting in the artist's home country, where authentic windmills from colonial times are still in evidence today. The present location of this work is not known. The scene portrayed is likely the town green in the village of East Hampton or Water Mill, NY.

The virtues of phaeton driving, a popular sport for young ladies, are depicted by Mr. Newton in a 1926 painting of *Miss Jean Browne Scott, Driving Newton Victor* (page 61). (The resemblance of the prize-winning horse's name to that of the artist is coincidental.) The horse, originally from the famed stables of Madame Drory de Perez, was imported in 1924 from Holland.

Mr. Newton's activities on his home turf were not limited to wielding a brush or following the hounds. "Artist Newton Had Wrong Man Arrested," ran a provocative headline in the September 10, 1926, issue of *The East Hampton Star*. "H. David Ives, a summer resident,'" the paper noted, had "been in the habit of driving over the Major's Path road…and had met Mr. Newton and the hounds on the road on numerous occasions." On this particular occasion, Mr. Newton "had the hounds out for a run and used the road so as to fool the dogs and make them think they were on a hunt" when "Mr. Ives drove up in his car and told him to get his dogs off his side of the road"; there ensued what was described, with commendable tact, as "some conversation," which, according to Mr. Newton, culminated in Mr. Ives threatening to "run over him and his hounds." The judge dismissed Newton's case for reckless driving, brought in error against an E. Benson Ives, as "a matter of mistaken identity," advised both plaintiff and intended defendant "that their actions 'in getting up in the air' were uncalled for," and called Mr. Newton's "attention to the rights of the public to half of the road at all times."

In 1927, Mr. Newton once again turned his talent to the production of two decorative four-panel room screens. *Over the Fence* (page 54) sold at Sotheby's in June 1993. Re-sold at auction in Maine in December of that year, its present location is not known. The second screen depicts a medieval scene with castles and eight knights riding with a pack of hounds. It is currently in the collection of a

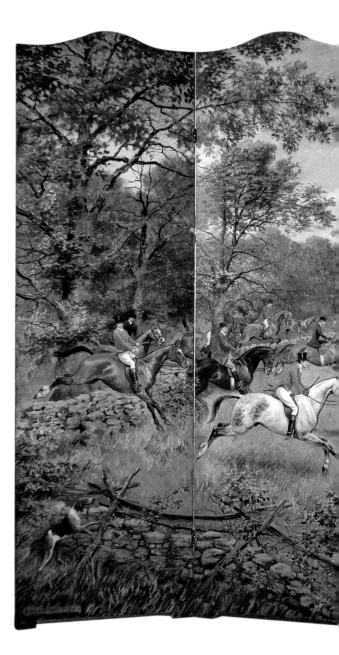

*Blue Ridge Hunt*, 1922. Oil on canvas, 20˝ x 71˝ room screen. Collection of the Museum of Hounds and Hunting, Leesburg, VA.

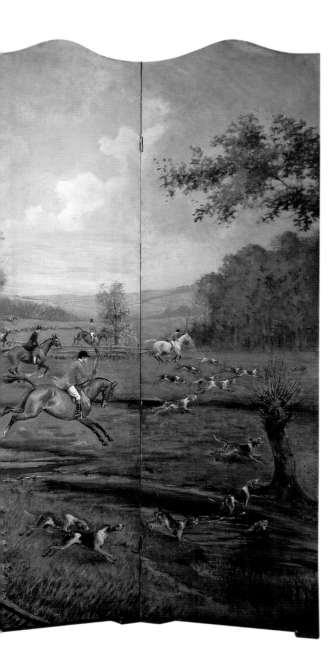

Pennsylvania family that acquired it from the artist. This subject matter was not unusual for Newton; auction records from Dunning's in 1996 show the sale of an undated Newton portrait of a knight reminiscent of his illustrations of knights and castles for the poem *Christalan*.

A sense of the environment in which Mr. Newton pursued his equestrian lifestyle during this period, apparently with undiminished vigor, is provided by the previously cited article in the September 9, 1927, issue of *The East Hampton Star* devoted to the third annual Horse Show hosted by the Riding Club of East Hampton. It offers a room-by-room tour of the "fine old" 1740 farmhouse, appropriately furnished with antiques, oriental rugs and artwork, that served as the club's "unique and altogether charming" headquarters on the Montauk Highway. Also described in meticulous detail are the grounds, featuring old apple trees that had been "fed and restored," "quaint old fashioned plants and boxwood," "hundred-year-old lilacs tended with loving care," as well as an old well-house brought from Riverhead to replace one that had "succumbed to old age," old sheds that were "shored up, carefully keeping the droop of age in them" and "old pine chairs and weatherbeaten benches…to invite the horseman to a stirrup-cup of cheering tea." An additional and doubtless more potent source of cheer to the horseman was the existence, "besides the Club grounds," of "twenty-six acres of paddocks, a polo field, horse show ring, exercising field, and stable enclosures."

In the course of outlining the history of horse sports in the Hamptons, it is noted that "Richard Newton, now Master of the Suffolk Hunt, was a pioneer in arousing interest in riding here. Years ago, in the late '90's, he owned three or four good horses; and gathered a group of other enthusiasts who met on the village green perhaps once a week in summer and set off on 'paper chases.' That was

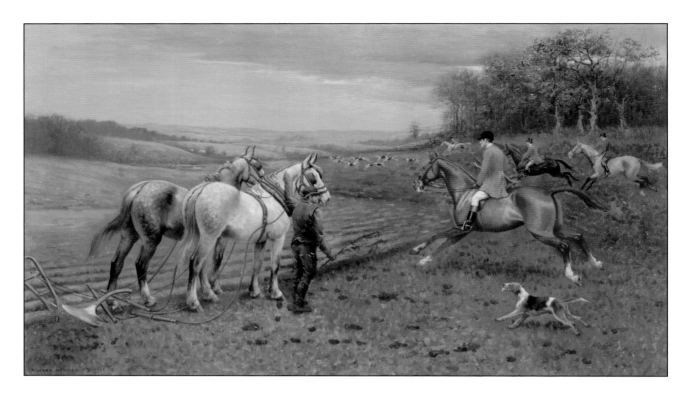

the first faint beginning of interest in horses for sporting purposes here. Mr. Newton formed the Suffolk Hunt Club at a farmhouse between here and Southampton; which was afterward converted into the residence of Thomas B. Clarke, next to Mr. Newton's own home."

His brother Francis receives credit for a dozen new stalls put in that year, having "designed these stables, after the Virginia model, around a little courtyard. Thoroughbreds lodge there in luxury…. The other day, perfectly groomed horses' heads looked out; and before each horse's door was his own measure, painted in the Club colors, and his own blanket….The view from the stables is very beautiful; the sweep of green polo field, with the blue ocean beyond; the blue and white of the judges' stand; the green trees surrounding the property; and the friendly horses in the paddocks nearby make a scene of utmost peace and happiness."

On occasions when its facilities served as the venue for events on the Hamptons' lively social calendar, however, the Club might more appropriately be described as the Roaring Twenties

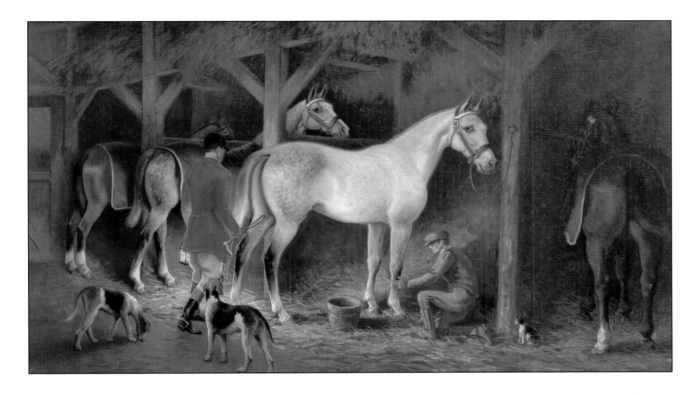

*Untitled (Early Morning Stable Scene)*, 1925. Oil on canvas, 26˝ x 44˝. Collection of Mr. and Mrs. Leonard W. Shoemaker, Banner Elk, NC.

incarnate. "Fifteen hundred persons witnessed the Riding Club's Fancy Dress Riding and Driving Party …and fifteen hundred more might easily have come without overtaxing the Club's broad green acres," reports *The East Hampton Star* on July 20, 1928. "Seven hundred were served at tea, in the Club house and under the trees." Mrs. Francis Newton was a member of the committee responsible for arranging the affair, who "were warmly congratulated on their achievement." Prizes were awarded "for the most original, most authentic, most beautiful and most comic entries" by a panel of judges that included the painter Childe Hassam.

"Leading the parade to band music was the G.O.P. elephant, with Dr. Ogden M. Edwards jr., as Herbert Hoover; as they passed the grandstand the elephant, inspired by the music, executed a few fancy steps of his own. Next came the Democratic donkey, ridden by Aubrey Slosson… as Al Smith, brown derby, big cigar and all, with a symbolic umbrella held aloft and watering cans tied on the donkey's sides. Next came Mr. Coolidge (Norman Barns) seated on a float with the banner reading

James Murphy, Whipper-in
of the Suffolk Hounds,
1924. Oil on canvas,
31 ˝ x 36 ˝. Private
collection, Ticonderoga, NY.

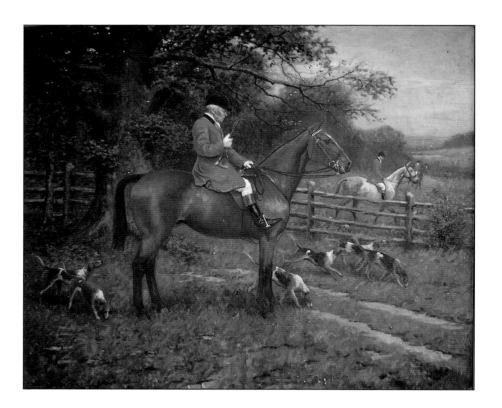

'I do not choose to run.' He was fishing in a dory with a huge can of worms at his side. Just as they passed the judges' stand Mr. Coolidge landed a big fish. The judges, regardless of party affiliations, awarded special prizes to all three entrants.

"First prize for the most beautifully costumed couple went to Mr. and Mrs. Winthrop Gardiner, who wore medieval costumes as Launcelot and Guinevere. Mr. Gardiner was in black and white velvet, while Mrs. Gardiner, her long hair unbound, wore silver cloth with pearl headdress and flowing veil.

"Richard Newton and Miss Audrey Jaeckel wore clown costumes with wide ruffles; and won first prize for comic costumes. Mr. Newton's horse was white, painted with black spots; he carried a cluster of colored balloons; Miss Jaeckel's horse was spotted with white and decorated with yellow.

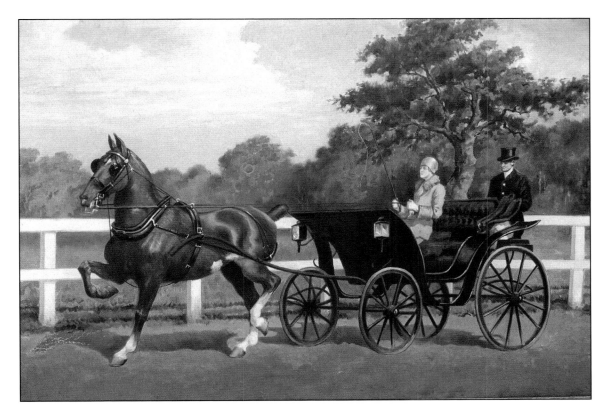

*Miss Jean Browne Scott, Driving Newton Victor,* 1926. Oil on canvas, 25˝ x 36˝. Collection of Mr. and Mrs.D. Weston Darby, Honey Brook, PA.

"Miss Judith Hamlin and Miss Elizabeth Gleason, as young Lochinvar and his stolen bride, won first prize for the most original couple. Miss Hamlin wore plaid kilts with Scotch tam, while Miss Gleason wore a bridal costume of silver lace over pink, elaborately trimmed with pearls."

Mr. and Mrs. Francis Newton were among "the Canterbury Pilgrims, an impressive party of twenty-one, including knights, nuns, friars, and attendants, [who] won first prize for beautiful groups. This was a pageant itself." Mrs. Edward T. Cockroft, who was the subject of two Newton portraits, "wore a bouffant yellow taffeta gown, flowered in red roses and trimmed with orange bows. Her hat was of black lace in an antique style." She was a passenger in Mrs. Harry L. Hamlin's 100-year-old stagecoach "Ocean Wave," which won first prize for "most authentic."

Others in this motley procession included Ben Hur in a scarlet chariot drawn by white circus horses; a turbaned Scheherezade; the Queen of Sheba atop a camel; a falconer clad in blue and yel-

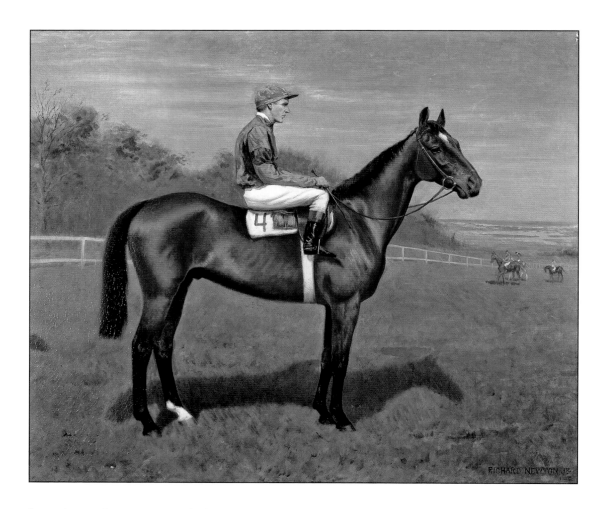

low velvet and carrying a similarly colored macaw; an Italian peasant and her trained monkey, the latter astride a "flea-sized burro, said to be the smartest in America"; and an assortment of Cossacks, Indians and gypsies. Following the parade and judging, tea and lemonade were served. Prohibition, after all, had not yet been repealed, although an uncharitable spectator might well have suggested that perhaps some participants in this pageant had found inspiration in their cups.

That same year, 1928, Richard Newton was inspired to paint another of his four-panel room screens, *Full Cry*. It has not been seen since it was sold at a Christie's auction in London in 1994.

According to members of the Collins family, Newton painted his second portrait of *Dr. Howard Collins, MFH*, around 1929, to be hung at the Riding Club in New York. After the club disbanded in the 1930's, this canvas of the master of Millbrook disappeared from view, only to be spotted in the 1950's by a friend of the family in an antiques shop on Third Avenue. It was purchased by Dr. Collins' son, who had it trimmed to a more manageable size and inscribed it with a facsimile of Newton's signature.

The location of two canvases from 1930 is still a mystery. Both were probably titled generically at auction. *Irish Setter* was sold in 1996, and a sporting portrait called *Master of Hounds* appeared at Sotheby's in 1987. The hunting canvas is signed and dated and depicts an unidentified gentleman in a scarlet coat, posed in profile, astride a grey hunter with a small pack of ten foxhounds by a stone wall.

It appears that in 1931 Mr. Newton went hunting in England. His painting of *The Cattistock Hunt*, executed that year, provides clear evidence of this excursion. In the book co-authored with his brother Maurice in tribute to their brother Francis, it is mentioned that Francis had often hunted abroad and rode with the Cattistock. Today the hunt is located primarily in West Dorset and a small section of Somerset. Historical records from Great Britain's M.F.H.A. indicate that it was known original-ly as the True Blue Hunt and was started by the Rev. W. Phillips of Cattistock Lodge, who hunted the country until 1806. Over the next fifty-odd years, J. J. Farquharson assumed the role of MFH, hunting the hounds at his own expense. Two of the hunt's notable masters were Parson Milne and an American, A. Henry Higginson. The great British sporting painter Thomas Blinks (1860-1912) caught the beauty of the hunt's Dorset coastal region in the painting *Ware Away, The Cattistock*.

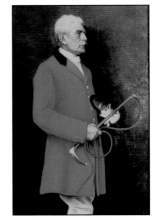

Another canvas dating from 1931 is the portrait of *Reginald Rives*, dressed in his coaching clothing (page 64). Rives, like his father, was a well-known "whip" who furthered the sport of four-in-hand driving in America. Newton also shared this expensive

*Dr. Howard D. Collins, MFH*, c.1929. Oil on can-vas, 30˝ x 25˝. Collection of Mr. and Mrs. Farnham Collins, Millbrook, NY. Cut down to its present size in the 1950's.

Portrait of Dr. Collins before it was altered.

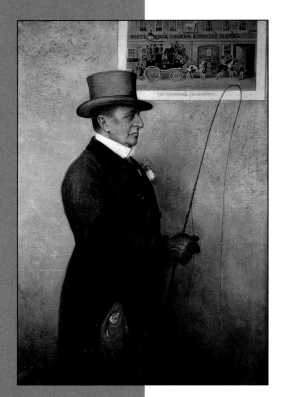

*Reginald Rives,* 1931.
Oil on canvas, 62 ″ x 40 ″.
Collection of the
Knickerbocker Club,
New York.

*Thomas Allison Riding
Pickles.* Aquatint.
Published by Melvile E.
Stone, At the Sign of the
Gosden Head,
New York, 1933.

and fashionable hobby, and was perhaps commissioned by a close friend, as was the case with many other paintings. In 1933, Reggie Rives became president of the Coaching Club. Today, the portrait hangs in the Knickerbocker Club in New York, a reminder of a bygone era.

With the arrival of the new decade, a fresh chapter opened in Mr. Newton's personal life, as noted on the "Social Page" of *The New York Times* on November 18, 1932, under the headline "Richard Newton Weds Mrs. Blanche Helier: Marriage of Broker's Widow and Painter and Huntsman Took Place in Connecticut." It is reported that "Mrs. Blanche Helier, widow of David Helier, who was a prominent cotton broker in this city before his death in June 1931, was married to Richard Newton of New York and Southampton about two months ago in a Connecticut town….Mrs. Newton's late husband, who was a partner in the firm Helier & Long, ended his life by suicide. They had three sons, Henry, Frederick and Ambrose Helier." Several other pertinent facts are found in the records of the Social Register Association, where it is noted that, prior to his death on June 16, 1931, Mr. Helier and his family resided at 4 E. 82nd Street in New York. Mr. Newton and Mrs. Helier, who must have been considerably younger, were married on October 20, 1932. Mrs. Helier-Newton died on August 3, 1975, having outlived her husband by twenty-four years. The couple had no children together.

During the year following his third marriage, Mr. Newton entered into a printmaking venture with Melville E. "Ned" Stone and his press, At the Sign of the Gosden Head, with the publication of an aquatint, *Thomas Allison Riding Pickles.* The date of the original oil is uncertain since the canvas has not been found. Allison was the legendary huntsman of the Meadow Brook Hounds for forty years, from 1911 to 1951. A signed aquatint appeared at a 1993 Christie's auction and anoth-

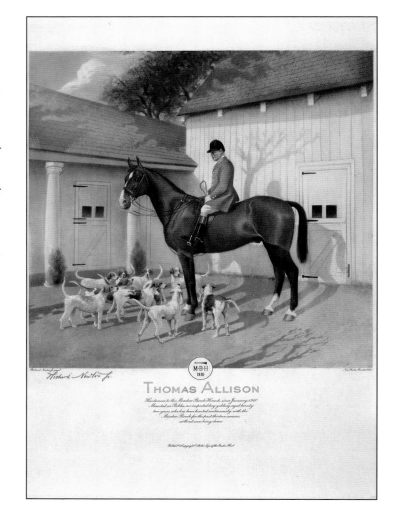

THOMAS ALLISON

Mr. and Mrs. Richard Newton, Jr., with Coach and Four in the Long Island Tercentenary Parade, East Hampton; Memorial Day, May 30, 1936. (Photo in Rattray, *Fifty Years at the Maidstone Club, 1891-1941*: 99.)

A MERRY CHRISTMAS
AND FOR THE NEW YEAR,
365 DAYS OF
HEALTH · HAPPINESS AND PROSPERITY!

er print is in the collection of the Museum of Hounds and Hunting, Leesburg, VA. It is believed that the painting's background is provided by the stables at Heyday House, the Davis estate in Upper Brookville, Long Island.

In celebration of Christmas 1933 the artist sent his foxhunting friends a photographic holiday card with the message "A Merry Christmas, and for the New Year, 365 Days of Health, Happiness and Prosperity!" One of these cards, found among the unpublished papers of Edward H. Carle, was signed by Mr. Newton and included the caption Meadowbrook–Smithtown Hunts at Southampton," which refers to a Long Island tri-meet, with the artist's Suffolk pack serving as the host hunt. Mr. Newton appears in the photo, second

A Christmas card sent by Richard Newton, Jr., to his friends in 1933.

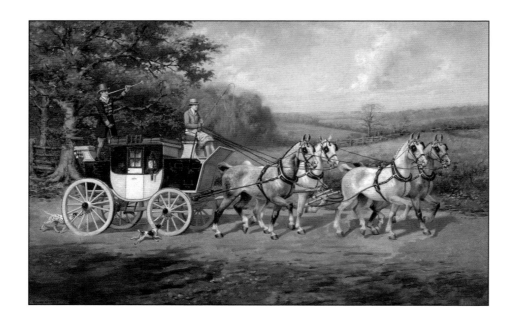

from the left, on a grey horse.

A photograph dated 1936 serves as an emblematic reference to this period in Richard Newton's life. *Mr. and Mrs. Richard Newton, Jr., with Coach and Four in the Long Island Tercentenary Parade, East Hampton,* is both a testament to the equestrian ability of the artist and evidence of the couple's social activities (page 65).

Two years later, in 1938, Newton painted one of his two known coaching pictures, which depicts Miss Jean Browne Scott in a Holland & Holland English road coach driving four grey horses. Himself a "whip," he had developed a first-hand familiarity with the subject. The coach was driven in the 1920's and '30's from the family estate in Valley Forge to Mr. Scott's Philadelphia office. The 20-mile journey required changing horses in Cynwyd at a small stable that the family maintained for that purpose. The names of the horses are unknown, but it is known that the "guard" with the coach horn is Chris Mulcahy.

# Blowing for Home: The Twilight of an Era

By the late 1930's, Richard Newton's life seems to have settled into a comfortable social and domestic routine. But tragedy was before long again to strike the Newton ménage. On November 9, 1939, the *East Hampton Star* reported the untimely death from pneumonia of Mrs. Newton's 36-year-old son, Frederick Helier, at his Georgica Road home.

The following year, at the age of 66, Richard Newton, Jr., signed and dated his penultimate known sporting canvas. The equestrian portrait of *Mrs. James H. Blackwell* (page 68), the former Margaret Melville, was given by the sitter to the Long Island Museum of American Art, History and Carriages at Stonybrook, NY, in 1990.

Another milestone in Newton's life occurred in 1941 when, according to Averill Geus in her history of the Maidstone Club, the sixteenth annual Riding Club horse show was held. "It was to be the last for many decades. The following year, no one had time for horse shows or riding. The men who had once tended the horses and the club had gone to war." By 1943 the club's 24-acre grounds had been sold and turned into potato fields. Over the next 60 years farming would all but cease in the area, as the demand for seaside residential property intensified and today's crowded Hamptons scene took shape.

The erosion of Richard Newton's world ushered in by the war years was, on a more personal level, reinforced by the death in 1941 of his only sister, Elizabeth (Bessie) Bosworth. Finally, for reasons that remain obscure, but which most likely included his advancing age, he decided to disband the Suffolk Hounds after the 1942 season, having served as its master since founding the club in 1902.

Mr. Newton experienced yet another death in the family a few years later when, as reported on the front page of *The East Hampton Star* on September 28, 1944, "Francis Newton died suddenly here just before seven o'clock last evening. He had been in poor health all summer, but few realized it, since he had looked very well." Born in 1872 in Lake George, NY, Francis was a little more than two years older than Richard, and the brothers were also close in temperament, as attested by their common interest in foxhunting and art. His obituary notes that Francis served as chairman of the Guild Hall Art Committee and was a member of the Maidstone Club, and that in addition to his wife, the former Amy James, he was survived by two brothers, Richard Newton, Jr., of Water Mill and New York, and F. Maurice Newton of New York. Services were held at his home, Fulling Mill Farm.

In an expression of their devotion for their older brother, Richard and Maurice privately printed a small memorial volume as a tribute to Francis in 1945. Opposite the title page is a vintage photograph of Francis outfitted for a morning hunt and posed on his field hunter as if he were sitting for one of Richard's paintings. It is the only image in the book, especially selected to celebrate Francis' enthusiasm for foxhunting.

As the brothers "wistfully recall matters that made up the loveliness of his life" they portray Francis' qualities of "great devotion and loyalty" and his ability to find "expression in terse and searching phrases that became family sayings." The book provides a glimpse into how Newton's parents encouraged their children's educated opinions, good manners, introspective pride and artistic expression within their privileged home at the close of the 19th century. The narrative offers details of early tutors, Francis' education in architecture at Columbia (class of '97), and days spent with "T-square and compass" at McKim, Mead & White.

Life's fleeting moments are recorded with deep affection and minute attention. Francis is shown learning to paint at the New York Art Students League, the Colarosi Atelier in Paris; and later in Wilmington with Howard Pyle, who expressed reservations about accepting a pupil "no longer at a beginner's age," noting that "he could not tell for three years whether or not he could make him a painter. After two months Mr. Pyle dismissed his uncertainty and said he then knew that Francis could paint." As a budding muralist, Francis "studied the great galleries of Europe" and "time and again went abroad and worked in the needed locale." Ultimately, because of a declining market for murals, he became a landscape painter. A few of his sojourns are described, including a winter in Malaga; a jungle painting trip during which he became "the fourth or fifth white man to see the great Kaiteur Falls" in British Guiana; and "one winter and spring many years ago" that he spent with Richard in Tangier, Morocco.

When the focus turns to foxhunting mention is made of his excursions with the Meadow Brook, Smithtown and, most particularly, Suffolk hunt clubs in America, and the Cattistock and South Dorset Hounds in Dorset, England. "A stickler for form," Francis, it is noted, "was always perfectly turned out, either in racing colors, mufti or in hunting scarlet, and no one...rode with

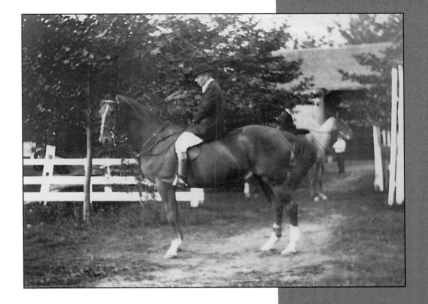

Francis Newton. Frontispiece of the memorial volume privately printed in 1945 by his brothers Richard and Maurice.

more grace, courage and enthusiasm." Richard, too, hunted with these clubs, as well as with Millbrook and several Virginia packs.

Richard Newton was 71 years old when, in 1945, he painted what appears to have been his last portrait. The subject was *John R. K. Scott*, who sat for him at his country home, Glenhardie. The artist had twice painted Mr. Scott's daughter Jean and her world-renowned driving horses. Scott, a Philadelphia attorney, was described in his *New York Times* obituary of December 10, 1946, as "a well known horseman" who "until 1930, each day that the weather was fair, drove from his country home near Valley Forge to his office…in a two-horse open carriage, or tally-ho."

In 1948, when Richard Newton was 74 years old, the printing firm of David and Aaron Ashley, Inc., of Yonkers, NY, began to publish photolithographs of several of his paintings: *Morning of the Hunt, Favorites, Stable of Champions, Grand Parade,* and a few other titles. Modern reprints of these posters may be found for sale online, but none of the original canvases, likely dating from 1910 to 1935, have been located.

The following winter, an additional link with the past was severed for Richard Newton with the death in East Hampton at the age of 79 on February 6, 1949, of Francis' wife, Amy, which was reported the following day by *The New York Times*. One of twelve children born to Henry James and the former Amy Belknap of Baltimore, she was survived by one sister, Mrs. Harry White of that city. *The East Hampton Star* on February 10th reported that her death had followed "a seven-weeks' illness" and outlined significant aspects of her life in which her brother-in-law Richard no doubt was intimately involved. She "first came to East Hampton to visit her brother, the late Henry James, at his dune home which was purchased several years ago by Juan Trippe"; and following her marriage in 1904 to Francis Newton the couple for many years "came to East Hampton summers and spent their winters abroad, in the west or in Florida." After purchasing the former Corwin farm at Georgica in 1911 they built a summer home there, which they called Fulling Mill Farm and where they established "one of the most outstanding herds of Jersey cattle" in the state of New York. Mr. and Mrs. Francis Newton "were very active in the social and civic life of East Hampton" and "were instrumental in the founding of the Maidstone Club and the East Hampton Riding Academy of which Mrs. Newton was for many years Chairman of the House Committee." She was a member of the Colony, Maidstone and Devon Yacht clubs.

Six years after he painted his last known portrait, the life of Richard Newton, Jr., came to an end. His death, at the age of 77 on April 19, 1951, was reported in *The New York Times* on April 21, 1951.

"Richard Newton Jr. of the Ambassador Hotel and of Box Farm, Water Mill, L. I., died on Thursday at the Harkness Pavilion, Columbia-Presbyterian Medical Center. He was well known in foxhunting circles both in this country and England, and had achieved some note as an artist of hunting scenes and horses, as well as for his portraits.

"A son of the late Rev. Dr. R. Heber Newton, formerly for thirty years rector of All Angels Protestant Episcopal Church here, Mr. Newton was a charter member of the Brook Club. He also belonged to the Turf and Field and Southampton Beach Clubs, the United Hunts of America, the National Steeplechase, Masters of Foxhounds and Hunt Associations of America. He was Master of the Suffolk Hounds, and acted as judge at many horse shows both in this country and England.

"He leaves his wife, Mrs. Blanche Helier Newton."

Following the death of her husband, Mrs. Blanche Ulman Newton, according to the *Blue Book of the Hamptons,* continued to reside at the Ambassador Hotel in the winter and Box Farm in the summer. Listed in the society handbook until 1975, Mrs. Newton had years earlier, on July 30, 1957, conveyed *Box Farm* for $1.00 to her son Henry Helier. Records show that two years later, on October 2, 1959, Mr. Helier in turn conveyed the property for $1.00 to his wife, Mary Anna Jensen Helier. It is interesting to note that these transfers continued a tradition established by Richard Newton, Jr., on October 28, 1935, when, as recorded in a National Trust report, he conveyed "Box Farm, its furniture, furnishings and contents therein to his wife Blanche Helier Newton for $1.00." The reason behind the transfer, sixteen years before his death, remains a mystery.

Mrs. Helier died on September 11, 1993, and under the terms of her will the National Trust for Historic Preservation acquired *Box Farm* in July of 1994. A comprehensive Architectural Report published in March 1995 states that the "property [was] managed by the Gifts of Heritage Program, whose role was to find a sympathetic buyer." Richard Newton's legacy, as the original

Box Farm, 1906

owner of his stepdaughter-in-law's property, is recorded in the report, although it arguably fails to recognize his role in establishing its dominant decorative motif:

"The hunting and horse prints which remain in the house are reminders of the Helier family interest in fox hunting and horse shows. Two significant photographs of the house taken in 1906 and 1932, which are part of the furnishings inventory record not only the configuration of the house at the turn of the century, but the Master of the Fox Hounds assembling the pack in front of the house. This gentleman on horseback has been identified as Richard Newton, known locally as 'Dickie,' who was Master of the Suffolk Hunt Club. His identification became the key to unfolding the ownership of the property and will no doubt serve to establish one of the occupants as important socially in Suffolk County."

In the mid-1950's two dancers of international acclaim, Alwin Nikolais and Murray Louis, purchased a timber-frame barn or studio structure on Box Farm from Mrs. Newton, which they moved, intact, along the Montauk Highway to their Southampton property. After this first element of their dacha-in-the-making had been relocated, they discovered in its attic more than twenty canvases of the local landscape and seaside, painted in the 1890's by Mr. Newton. Mentioning their discovery, which also included some household items and furniture, to Mrs. Newton, they were pleased to learn, as Mr. Louis put it, that they had "purchased the old building and its contents and that she certainly did not want any of that old junk back." Some of their rescued paintings have since been cleaned and repaired; several were given to local museums and to friends and neighbors who now took pleasure in the beauty of sea and countryside that had so captivated the young painter.

When *Box Farm* and its furnishings were in their turn sold by the National Trust in 1995, the new owner reported that no Newton paintings were found hanging in the house and that many items on the Trust's inventory were missing. Still in the library of Mr. Newton's former home, however, were leather-bound copies of *A Small Girl's Stories* and *Poems in Passing* by Grace Clarke, and the two vintage photographs of the farm that were mentioned in the National Trust report. These were subsequently given to the author.

But for the ephemeral relics of a vanished world—those fragile documents of paper, canvas and pigment—little would remain to remind succeeding generations of an era so recent and yet, with its passing from living memory, so rapidly receding into the veiled realm of history.

Fragmentary though they may be, such artifacts serve to preserve moments from the past; frozen in time, they remain as fresh as when they were recorded.

It scarcely seems that a century has passed since Grace Clarke Newton, on September 29, 1906, was inspired to commit to paper, under the heading "Thicket Gate," an episode in her life with Richard Newton that must have moved her almost beyond words. "A note found written on the back of a map of the run of the Suffolk Hounds," is his cryptic description of a document that clearly held a special significance for him as well, and which he selected as the concluding item in *Poems in Passing*, the volume of her writings that Richard Newton published as a memorial to his beloved and prematurely departed companion.

Richard Newton, Jr, MFH, with hounds, in front of Box Farm, 1932.

> After this run, which was one of the most beautiful I ever saw ( Dick riding "Tornado"), I came back here, lit the lamps, got tea ready, and then when Dick rode in he saw the light shining from our own little house ; he blew a "salute" on his hunting-horn and, in his pink coat, came home to tea.   It is a memory long —no, ever—to be cherished.
>
> G. C. N.

# Bibliography

American Federation of the Arts. *American Art Annual, Vol.18*. Washington, DC: American Federation of the Arts, 1921: 312.

Art Sales Index Ltd. *The Art Sales Index,* 20th Edition. Surrey, England: Art Sales Index Ltd., 1987-88, Vol. II: 1360.

*Baily's Hunting Directory.* London, England, 1930-1940.

Benezit, E. *Dictionary of Artists*, 14 vols. Paris: Gründ, 2006, Vol. 10: 295-296.

Castagno, John. *American Artists: Signatures and Monograms, 1800-1989*. Metuchen, NJ, & London: The Scarecrow Press, Inc., 1990: 489.

Chadbourne, Janice H., Karl Gabosh and Charles O. Vogel. *The Boston Art Club Record, 1873-1909*. Madison, CT: Sound View Press, 1991: 13,14, 285.

Clarke, Grace (Grace Clarke Newton). *A Small Girl's Stories*. New York: E. P. Dutton & Co., 1916. (Printed by De Vinne Press, six copies.)

Davenport, Raymond J., ed. *Davenport's Art Reference & Price Guide, 1999/2000*. Phoenix, AZ: Gordon's Art Reference, Inc.: 1257.

Davenport, Raymond J., ed. *Davenport's Art Reference & Price Guide, 2001/2002*. Phoenix, AZ: Gordon's Art Reference, Inc.: 1364.

Falk, Peter H., ed. *Annual Exhibition Record of the Art Institute of Chicago*. Madison, CT: Sound View Press, 1990: 652.

Falk, Peter H., ed. *Annual Exhibition Record, 1901-1950, National Academy of Design*. Madison, CT: Sound View Press, 1990: 380.

Falk, Peter H., ed. *Who Was Who in American Art. 1564-1975, 400 Years of Artists in America.* Three volumes. Madison, CT: Sound View Press, 1999, Vol. II: 2417.

Fielding, M. *Dictionary of American Painters, Sculptors and Engravers*. Philadelphia, 1926.

Fleitmann, Lida L. (Mrs. J. Van S. Bloodgood, Ex. M.F.H.). *Hoofs in the Distance*. Foreword by A. Henry Higginson, Ex. M.F.H.; Decorations by Lida Lacey Bloodgood (Princess Dominique Radziwill). New York and Toronto: D. Van Nostrand Company, Inc., 1953. (Limited edition of 985 signed and numbered copies; designed and edited by Eugene V. Connett.)

Geus, Averill D. *The Maidstone Club, 1941-1991, The Second Fifty Years.* West Kennebunk, ME: Phoenix Publishing, 1991: 28, 34.

Higginson, A. Henry and Julian Ingersoll Chamberlain. *Hunting in the United States and Canada.* Garden City, NY: Doubleday, Doran, 1928.

Higginson, A. H. and J. I. Chamberlain. *The Hunts of the United States and Canada.* Boston, MA: F. Wiles, 1908.

Mallett, Daniel T. *Mallett's Index of Artists.* New York: R.R. Bowker Co., 1948.

*Mayer International Auction Records 1999, Vol. II, K-Z, Auction Prices.* Lausanne: Editions Acatos, 1999: 3518.

Mackay-Smith, Alexander. *The American Foxhound, 1747-1967.* The American Foxhound Club,1968.

Naylor, Maria, ed. *The National Academy of Design Exhibition Record, 1861-1900; Vol. II, M through Z.* Tombstone, AZ: Printed by The Tombstone Epitaph for the Kennedy Galleries, Inc., 1973: 684.

Newton, Grace Clarke. *A Hunting Alphabet: The ABC of Drag Hunting.* Illustrated by Richard Newton, Jr. New York: E. P. Dutton & Co., 1917. (Printed by Redfield-Kendrick-Odell & Co., New York; 262 copies.)

Newton, Grace Clarke. *Poems in Passing.* New York: E. P. Dutton & Co., 1916. (Printed by The De Vinne Press; 152 copies.)

Newton, Richard, Jr. The Glorious Sport of Polo. *Munsey's Magazine*, October 1900: 44-54.

Newton, Richard, Jr. Riding to Hounds. *Munsey's Magazine*, October 1899: 73-84.

Newton, Richard, Jr., and F. Maurice Newton. *Francis Newton.* (Privately printed by the George Grady Press, New York, 1945; 100 copies.)

O'Dea, Joseph C. *Horses and Hounds of the Genesee.* Geneva, NY: W. F. Humphrey Press Inc., 1973.

*Personal Name Index to The New York Times Index*, 1851-1974, Falk and Falk, Roxbury Datainterface, Succasunna, NJ.

Ralston Galleries. Exhibition of Recent Portraits by Richard Newton, Jr., from April Ninth to Twenty-second Inclusive. Ralston Galleries, 1916. (Leaflet in the collection of the Frick Art Reference Library, New York.)

Rattray, Jeannette Edwards. *Fifty Years of the Maidstone Club, 1891-1941.* East Hampton, NY: Maidstone Club, 1941:99

Trask, Katrina (Nichols). *Christalan.* Illustrated by Richard Newton, Jr. New York and London: G. P. Putnam's Sons (The Knickerbocker Press), 1903.

Van Urk, J. Blan. *The Story of American Foxhunting: From Challenge to Full Cry, 1865-1906, Vol. II.* New York: Derrydale Press, 1941: 146, 225, 300, 306.

Wadsworth, W. Austin. *The Hunting Dairies of W. Austin Wadsworth, MFH.* Geneseo, NY: Genesee Valley Hunt, 1984.

Wadsworth, William P., MFH. *Riding to Hounds in America: An Introduction for Foxhunters.* Geneseo, NY: The Chronicle of the Horse, Inc., 1959.

*Who's Who in American Art, Vols. 1-18.* Chicago, 1899-1934.

# Chronology of Sporting Art by Richard Newton, Jr

*Orange County Stafford '99*, 1906. Oil on canvas. Location unknown. Photograph in Peter A. Juley & Son Collection, Smithsonian American Art Museum, Washington, DC (J0118446). (Page 32)

*Orange County Ranta,* 1906. Oil on canvas. Location unknown. Photograph in Peter A. Juley & Son Collection, Smithsonian American Art Museum, Washington, DC ((J0011169) (Page 31)

*John R. Townsend, MFH, Riding Greek Dollar,* 1906. Oil on canvas, 43 ¾″ x 54 ½″. The Long Island Museum of American Art, History and Carriages, Stony Brook, NY. Gift of Mrs. J.V.S. Bloodgood, 1964. (Page 12)

*The Orange County Hunt*, 1906. Oil on canvas. Destroyed by fire, 1968. Photographed by A. F. Bradley. (Page 32)

*Orange County Hunt on a Run*, c. 1906. Oil on canvas. Photograph among Lida. F. Bloodgood Papers, National Sporting Library, Middleburg, VA. Location unknown. Pictured are (l. to r.), J. R. Townsend, MFH; S. C. Glascock, whipper-in; and William Skinner, huntsman. (Page 34)

*Robert Livingston Gerry*, 1906. Oil on canvas, 44″ x 54″. Collection of Mrs. John B. Hannum, Unionville, PA. (Page 36)

*Miss Cornelia Harriman*, 1907. Oil on canvas, 28″ x 40″. Collection of Mrs. John B. Hannum, Unionville, PA. (Page 35)

*James K. Maddux, MFH, Riding Shining Light,* 1908. Oil on canvas, 40″ x 50″. The Museum of Hounds and Hunting, Leesburg, VA. (Page 33)

*Mrs. James K. Maddux, Riding Grey Cap,* 1908. Oil on canvas, 40″ x 50″. Reproduced in Chicago Art Galleries Auction catalog, Chicago, IL, 1968. Location unknown. (Page 34)

*Lifting the Pack to the Next Covert, No.3,* 1910. Oil on canvas, 38″ x 28″. Collection of Helen T. Johnson, Bristol, CT. (Page 37)

*The Pups "Meet," Heyday House Terriers,* 1910. Oil on canvas, 9″ x 22″. Collection of Bruce E. Balding, Litchfield, CT. (Page 38)

*Joseph E. Davis, MFH*, 1911. Oil on canvas, 40″ x 50″. Collection of Bruce E. Balding, Litchfield, CT. Reproduced in *A Hunting Alphabet: The ABC of Drag Hunting*, by Grace Clarke Newton, 1917; and in *Country Life*, September 1919. (Page 40)

*Lady Dilham*, 1911. Oil on canvas, 28″ x 38″. Collection of Dr. William R. Mimms, Wilmore, KY. (Page 39)

*Rock Sand*, 1911. Oil on canvas, 26″ x 35″. Collection of The Jockey Club, New York. (Presented to The Jockey Club June 1916 by F. K. Sturgis.) (Page 43)

*Dr. Howard D. Collins, MFH, Riding Brisk*, 1914. Oil on canvas, 39″ x 32″. Collection of Mr. and Mrs. Farnham Collins, Millbrook, NY. (Page 41)

*Catherine Louise Littauer, Riding Shawinigan,* 1914. Oil on canvas, 40″ x 40″. Collection of Mrs. William D. Doeller, Orlean, VA. (Page 42)

*Miss Mercedes Crimmins*, before 1915. Oil on canvas. Shown at the Ralston Galleries, NY, 1915. Location unknown.

*Major W. Austin Wadsworth, MFH, Riding Devilkin*, 1915. Oil on canvas, 34″ x 46″. Collection of the Wadsworth Homestead, Geneseo, NY. Reproduced in *A Hunting Alphabet: The ABC of Drag Hunting*, by Grace Clarke Newton, 1917. A plaque on the frame is inscribed, "Presented by the Members of the Genesee Valley Hunt on the 35th Anniversary of his Mastership, October 1915. In Grateful Acknowledgement of Many a Good day." (Page 47)

*William P. Wadsworth, Riding a Hinny with a Lone Hound*, 1915. Oil on canvas, 20″ x 24″. Collection of the Wadsworth Homestead, Geneseo, NY. (Page 45)

*Mrs. E. T. Cockcroft*, before 1916. Oil on canvas. Shown at the Ralston Galleries, NY, 1916. Location unknown.

*Howard Davidson*, before 1916. Oil on canvas. Shown at the Ralston Galleries, NY, 1916. Location unknown.

*Rufus C. Finch, MFH, Watchung Hunt*, before 1916. Oil on canvas. Shown at the Ralston Galleries, NY, 1916. Location unknown.

*Robert Gilmore Esq., at the Smithtown Hunt,* before 1916. Oil on canvas. Shown at the Ralston Galleries, NY, 1916. Location unknown.

*Miss Laura Harding*, before 1916. Oil on canvas. Shown at the Ralston Galleries, NY, 1916. Location unknown.

*Miss Dorothy Schieffelein,* before 1916. Oil on canvas. Shown at the Ralston Galleries, NY, 1916. Location unknown.

*Mrs. James A. Stillman,* before 1916. Oil on canvas. Shown at the Ralston Galleries, NY, 1916. Location unknown.

*Mr. F. K. Sturgis*, before 1916. Oil on canvas. Shown at the Ralston Galleries, NY, 1916. Location unknown.

*Mrs. Robert E. Tod, Riding Sceptre,* before 1916. Oil on canvas. Shown at the Ralston Galleries, NY, 1916. Location unknown.

*Mr. John Tucker, Riding Culvert,* before 1916. Oil on canvas. Shown at the Ralston Galleries, NY, 1916. Location unknown.

*Master Stephen Von Pfizenmeyer,* before 1916. Oil on canvas. Shown at the Ralston Galleries, NY, 1916. Location unknown.

*Alphonso,* before 1916. Oil on canvas. (Polo pony owned by Alex Smith Cochrane.) Shown at the Ralston Galleries, NY, 1916. Location unknown.

*Untitled (Hunter Barn),* 1916. Oil on canvas, 30″ x 36″. Collection of Mrs. James McCormick, Middleburg, VA. (Page 46)

*Mrs. E. T. Cockcroft, Riding Danger,* before 1917. Oil on canvas. Reproduced in *A Hunting Alphabet: The ABC of Drag Hunting,* by Grace Clarke Newton, 1917. Location unknown. (Page 48)

*Benjamin Nicoll, Esq.—Essex Hunt (on Cocktail),* before 1917. Oil on canvas. Reproduced in *A Hunting Alphabet: The ABC of Drag Hunting,* by Grace Clarke Newton, 1917. Location unknown. (Page 49)

*Drawn Blank,* before 1917. Oil on canvas. Reproduced in *A Hunting Alphabet: The ABC of Drag Hunting,* by Grace Clarke Newton, 1917. Location unknown. (Page 48)

*A Few of the Right Sort,* before 1917. Oil on canvas. Reproduced in *A Hunting Alphabet: The ABC of Drag Hunting,* by Grace Clarke Newton, 1917. Location unknown. (Page 49)

*The Grey Hunt Team—Suffolk Hounds,* before 1917. Oil on canvas. Reproduced in *A Hunting Alphabet: The ABC of Drag Hunting,* by Grace Clarke Newton, 1917; and in *Country Life,* September 1919, titled *In the Glade.* Location unknown. (Page 13)

*A Hunting Morn,* before 1917. Oil on canvas. Reproduced in *A Hunting Alphabet: The ABC of Drag Hunting,* by Grace Clarke Newton, 1917; and as a photo-lithograph, hand-titled *Foxy Quillet,* 1948. Location unknown. (Page 51)

*Oakleigh Thorne, MFH,* 1917. Oil on canvas, 29″ x 55″. Collection of Mr. and Mrs. Oakleigh Thorne, Millbrook, NY. Inscription reads: "Presented to Oakleigh Thorne, MFH, by the residents of Millbrook in appreciation of his devoted efforts in making Millbrook a hunting country." Reproduced in *A Hunting Alphabet: The ABC of Drag Hunting,* by Grace Clarke Newton. (Page 50)

*The Adjutant of Squadron "A",* before 1917. (Probably a portrait of Newton's brother-in-law, Thomas B. Clarke, Jr.) Shown at the Ralston Galleries, NY, 1917. Location unknown.

*Mrs. Helen Buchanan Jones, Riding Katydid,* 1917. Oil on canvas, 30 ¼″ x 39″. Collection of Mrs. William S. Stokes III, Upperville, VA. (Page 44)

*Master Luther Tucker,* 1918. Oil on canvas. Photograph in Peter A. Juley & Son Collection, Smithsonian American Art Museum, Washington, DC (J0024488). Location unknown. (Page 50)

*Nala,* 1919. Oil on canvas, 28″x 36″. Collection of Dr. Edward Mahoney, Milton, MA. (Page 53)

*A Horse and a Terrier in a Stable,* 1919. Oil on canvas, 20 ¼″ x 24″. Sold at Sotheby's, New York, June 8, 1990. Location unknown.

*Daniel Cox Sands, MFH of the Middleburg and Piedmont Hunt,* 1920. Oil on canvas, 37″ x 50″. Collection of the Middleburg Community Center, Middleburg, VA. (Page 52)

*Blue Ridge Hunt,* 1922. Oil on canvas, 20″ x 71″ room screen. Collection of the Museum of Hounds and Hunting, Leesburg, VA. (Page 56)

*The Fox Hunt,* 1924. Oil on canvas, 35″ x 60″. Sold at Sotheby's, New York, June 3, 1994. Location unknown.

*James Murphy, Whipper-in of the Suffolk Hounds,* 1924. Oil on canvas, 31″ x 36″. Private collection, Ticonderoga, NY. (Page 60)

*Untitled (Early Morning Stable Scene),* 1925. Oil on canvas, 26″ x 44″. Collection of Mr. and Mrs. Leonard W. Shoemaker, Banner Elk, NC. (Page 59)

*Untitled (Hunt Scene and a Farmer's Team),* 1925. Oil on canvas, 26″ x 44″. Collection of Mr. and Mrs. Leonard W. Shoemaker, Banner Elk, NC. (Page 58)

*Miss Jean Browne Scott, Driving Newton Victor,* 1926. Oil on canvas, 25″ x 36″. Collection of Mr. and Mrs. D. Weston Darby, Honey Brook, PA. (Page 61)

*Over the Fence,* 1927. Oil on canvas, 24″ x 72″ room screen. Sold at Sotheby's, New York, June 4, 1993. Location unknown. (Page 54)

*Untitled (Full Cry),* 1928. Oil on canvas, 23 ½″ x 71 ½″ room screen. Sold at Christie's, London, May 13, 1994. Location unknown.

*Dr. Howard D. Collins, MFH,* c.1929. Oil on canvas, 30″ x 25″. Collection of Mr. and Mrs. Farnham Collins, Millbrook, NY. Cut down to its present size in the 1950's. (Page 63)

*Portrait of an Unknown Master of the Hounds,* 1930. Oil on canvas, 26″ x 32″. Sold at Sotheby's, New York, June 4, 1987. Location unknown.

*Irish Setter,* 1930. Oil on canvas laid on board, 40″ x 60″. Sold at Du Mouchelle, Detroit, MI, August 14, 1998. Location unknown.

*Reginald Rives,* 1931. Oil on canvas, 62″ x 40″. Collection of the Knickerbocker Club, New York. (Page 64)

*The Cattistock Hunt,* 1931. Oil on canvas, 26″ x 32″. Collection of James M. Kilvington, Dover, DE.

*Miss Jean Browne Scott, Driving Four Gray Horses,* 1938. Oil on canvas, 35″ x 52″. Collection of Mr. and Mrs. Stuart Quillman, Kennett Square, PA. (Page 66)

*Mrs. James H. Blackwell,* 1940. Oil on canvas, 37″ x 54 ¾″. Collection of the Long Island Museum of American Art, History & Carriages, Stony Brook, NY. Gift of Mrs. James H. Blackwell, 1990. (Page 68)

*John R. K. Scott,* 1945. Oil on canvas. Location unknown.

## Undated Sporting Paintings

*Beagle Pack with Huntsman.* Oil on canvas. Published on front cover of *The Spur*, September 1, 1926. Location unknown. (Page 53)

*Coaching Scene.* Oil on canvas. Photograph among Lida. F. Bloodgood papers, National Sporting Library, Middleburg, VA. Location unknown. (Page 23)

*Full Cry*. Oil on canvas, 24″ x 32 ⅜″. Appeared at Sotheby's, New York, June 8, 1990. Location unknown.

*Horses Grazing*. Oil on canvas, 24″x 32″. Sold at Sotheby's Arcade, NY, December 18, 1991. Location unknown.

*Lida L. Fleitmann, Riding Gypsie Queen*. Oil on canvas. Only a 6 ⅞″ x 8 ⅛″ fragment—of the horse's head and neck—survives. It is preserved, along with a photograph of the entire painting, among the Lida F. Bloodgood papers at the National Sporting Library, Middleburg, VA. (Pages 24, 25)

*Portrait of a Racehorse and Jockey*. Oil on canvas, 28″ x 34″. Collection of the Museum of Hounds and Hunting, Leesburg, VA. Gift of Dr. and Mrs. Edward Mahoney. (Page 62)

*Untitled (Hunt Staff Moving the Pack)*. Oil on canvas, 27″ x 38″. Signed. Collection of Mrs. Gladys Maupin Leake, Charlottesville, VA.

## Sporting Prints, Posters and Aquatints

*Thomas Allison Riding Pickles*. Aquatint. Published by Melvile E. Stone, At the Sign of the Gosden Head, New York, 1933. (Page 64)

*Morning of the Hunt*. Photo-lithograph. Published by Aaron Ashley, Inc., Yonkers, NY, 1948.

*Favorites*. Photo-lithograph. Published by Aaron Ashley, Inc., Yonkers, NY, 1948.

*Grand Parade*. Photo-lithograph. Published by David Ashley, Inc., Yonkers, NY, 1948.

*Stable of Champions*. Photo-lithograph, 20″ x 24″. Published by David Ashley, Inc., Yonkers, NY. 1948.

*Foxy Quillet*. Photo-lithograph, 15″ x 18″. Published by David Ashley, Inc., Yonkers, NY. Signed by the artist and inscribed on the back: "Dr. Howard D. Collins, 50 West 55th Street. From one who loves a gray to one who has a good one!" Collection of Mr. and Mrs. Farnham Collins, Millbrook, NY. (Page 51)

## Chronology of Nonsporting Art by Richard Newton, Jr.

*Children of Atlantis,* 1891. Watercolor. Exhibited at the Boston Art Club, 1891. Location unknown.

*Waiting,* 1891. Watercolor. Exhibited at the Boston Art Club, 1891. Location unknown.

*Even Song,* 1891. Exhibited at the National Academy of Design, 1891. Location unknown.

*Two White Swans All White as Snow,* 1891. Watercolor. Exhibited at the Art Institute of Chicago, 1891. Location unknown.

*Untitled, Long Island Salt Marsh,*1892. Oil on canvas, 16″ x 30″. Collection of Ellerslie Farm, Washington, VA.

*Voice From the Sea,* 1893. Exhibited at the National Academy of Design, 1893. Location unknown.

*Italian Slaves*, 1893. Watercolor. Exhibited at the Boston Art Club, 1893. Location unknown.

*Untitled, Spring, Long Island Salt Marsh*, 1893. Oil on canvas, 16″ x 30″. Collection of Ellerslie Farm, Washington, VA.

*Untitled, Haystacks and Long Island Salt Marsh,* 1893. Oil on canvas, 16″ x 30″. Collection of Murray Louis, New York, NY.

*Untitled, Haystacks at Full Moon, Long Island Salt Marsh,* 1893. Oil on canvas, 15 ½″ x 30″. Collection of Murray Louis, New York, NY.

*Marsh and Mere,* 1893. Oil on canvas, 16″x30″. The Parrish Art Museum, Littlejohn Collection, Southampton, NY. (Page 14)

*Untitled, Beach Scene, Long Island,* 1894. Oil on canvas, 15 ¾″ x 30″. Sold at Phillips, du Pury and Luxembourg, November 28, 2000. Location unknown.

*At Sunset,* 1895. Exhibited at the National Academy of Design, 1895. Location unknown.

*Harvest Moon,* 1895. Exhibited at the National Academy of Design, 1895. Location unknown.

*Spring Idyll,* 1895. Watercolor. Exhibited at the Boston Art Club, 1895. Location unknown.

*A Moorish Sentinel,* 1895. Watercolor. Exhibited at the Annual Exhibition of the Art Institute of Chicago, 1895. Location unknown.

*An Aristocrat of Cairo,* 1895. Watercolor. Exhibited at the Annual Exhibition of the Art Institute of Chicago, 1895. Location unknown.

*The Green Sea,* 1895. Exhibited at the Annual Exhibition of the Art Institute of Chicago, 1895. Location unknown.

*Woodland Scene,* 1897. Oil on canvas, 30″ x 16″. The Parrish Art Museum, Littlejohn Collection, Southampton, NY.

*Untitled, Morocco, Children Tending Sheep,* 1898. Oil on canvas, 48″ x 66″. Inscribed "Morocco." Sold at Kamelot Auction, Philadelphia, May 7, 2005. Location unknown.

*Untitled, Morocco,* 1899. Oil on canvas, 60 ¼″ x 48″. Sold at William Doyle, New York, NY, October 3, 2001. Location unknown.

*Last Rays on Cape Malabat, Morocco,* 1899. Exhibited at the Annual Exhibition of the Art Institute of Chicago, 1899. Location unknown.

*Old Moorish Bridge on the Way to Tetuan, Morocco,* 1900. Exhibited at the National Academy of Design, 1900. Location unknown.

*Late November in New Jersey,* 1901. Exhibited at the National Academy of Design, 1901. Location unknown.

*Untitled, Dunes and Sea,* 1910. Oil on canvas. Collection of Helen Johnson, Bristol, CT. ("My mother and father [who lived in New York and Bronxville in Westchester County] may have bought this painting from Mr. Newton.")

*Sunlight on the Porch #1*, 1916. Oil on canvas. Exhibited at the Ralston Galleries, New York, NY, 1916. Location unknown.

*Sunlight on the Porch #2*, 1916. Oil on canvas. Exhibited at the Ralston Galleries, New York, NY, 1916. Location unknown.

*Lingering Light, Dunes Towards Amagansett, L.I.,* 1916. Oil on canvas. Exhibited at the Ralston Galleries, New York, NY, 1916. Location unknown.

*Cocker Spaniels of Mrs. Marcellus Hartley Dodge*, 1916. Oil on canvas. Exhibited at the Ralston Galleries, New York, NY, 1916. Location unknown.

*Untitled, Beached Boats Along the Dover Coast*, 1924. Oil on canvas, 23″ x 31″. Sold at estate auction, C. G. Sloan Co., Bethesda, MD, July 5, 1991. Location unknown.

*Untitled, Fishing Boats at the Shore*, 1924. Oil on canvas. Appeared in auction at Weschler's, May 18, 1991.

*Untitled, Normandy Coast*, 1924. Oil on canvas, 23″ x 31 ½″. Sold at Weschler's, October 2, 1993.

*Untitled, Medieval Scene—Room Screen,* 1927. Oil on four canvas panels. Collection of Susan Louderback, Wayne, PA. ("I remember my grandmother [1900-1968] from Brooklyn, NY, had this screen depicting a castle, with eight knights on horses and a pack of hounds, in her dining room.")

## Undated Nonsporting Art

*Untitled, Tangiers, Morocco.* Oil on canvas, 23″ x 29″. Sold at Susanin's, Chicago, IL, September15, 1996. Location unknown.

*Untitled, Knight.* Oil on canvas, 13″ x 23″. Sold at Dunning's, Elgin, IL, December 1, 1996. Signed and annotated: "Richard Newton, Tangier, Morocco." Location unknown.

*Untitled, Bermuda,* c.1914. Oil on canvas, 23″ x 30″. Collection of Farnham Collins, Millbrook, NY. ("My grandparents spent many summers in Bermuda and invited Newton one year at least.")

*Untitled, Beach Scene, Long Island.* Oil on canvas, 18″ x 30″. For sale July 2002 at Terry Wallace Gallery, East Hampton. Location unknown.

*Untitled, Unfinished Long Island Seascape.* Oil on canvas, 16″ x 30″. Collection of Ellerslie Farm, Washington, VA.

*Untitled, European Fishing Harbor.* Oil on canvas, 16″ x 30″. Collection of Ellerslie Farm, Washington, VA.

*Untitled, Long Island Seascape.* Oil on canvas, 16″ x 30″. Collection of Ellerslie Farm, Washington, VA.

*Untitled, Full Moon, Long Island Seascape.* Oil on canvas, 16″ x 30″. Collection of Ellerslie Farm, Washington, VA.

*Untitled, Long Island Bay.* Oil on canvas, 16″ x 30″. Collection of Ellerslie Farm, Washington, VA.

*Untitled, Male Model.* Oil on canvas, 20″ x 24″. Perhaps a study of a model from the William M. Chase school. Collection of Murray Louis, New York, NY.

*Untitled, Male Model in Profile.* Oil on canvas, 11″ x 14″. Canvas fragment. Figure leaning on a broom. Perhaps a study of a model from the William M. Chase school. Collection of Murray Louis, New York, NY.

*Untitled, Summer Landscape.* Oil on canvas, 16″ x 30″. Collection of Murray Louis, New York, NY.

*Untitled, Spaniel Portrait.* Oil on canvas, 10″ x 12″. Full-face, low-key colors, sweet sensitive eyes. Collection of Murray Louis, New York, NY.

*Untitled, Sag Harbor Summer Landscape.* Oil on canvas, 16″ x 30″. Church steeple and small buildings in twilight. Collection of Frederick Baker, Southampton, NY; gift of Murray Louis.

*Untitled, Moored Sailboats.* Oil on canvas, 16″ x 30″. Boats in marsh against a lovely pink sky. Collection of Frederick Baker, Southampton, NY; gift of Murray Louis.

*Untitled, Sailboats on Mecox Bay.* Oil on canvas, 16″ x 30″. Bright summer day, vivid blue ocean filled with boats with white sails. Collection of Marisa Miller, Southampton, NY; gift of Murray Louis.

*Untitled, Spring Landscape.* Oil on canvas, 16″ x 30″. Long Island (?) hills, winding stream. Collection of Murray Louis, New York, NY.

*Untitled, Winter Haystack.* Oil on canvas, 16″ x 30″. Collection of Murray Louis, New York, NY.

*Untitled, Spring Plowing.* Oil on canvas, 16″ x 18″. Farmer and his plow team of two horses, a gray and a chestnut, at rest by a salt marsh. Collection of Murray Louis, New York, NY.

*Untitled, Bay Horse in a Field.* Oil on canvas, 28″ x 30″. Very dark canvas, removed from stretcher, of a horse in profile. Collection of Murray Louis, New York, NY.

*Untitled, Gray and Bay Horse Study.* Oil on canvas, 16″ x 30″. Unfinished and damaged. Collection of Murray Louis, New York, NY.

*Untitled, Farm Lane in Springtime.* Oil on canvas, 16″ x 30″. Fences along a farm lane winding up a hill to a barn. Collection of Murray Louis, New York, NY.

*Untitled, Gentleman's Portrait.* Oil on canvas, 20″ x 24″. A low-key study of a dignified, scholarly face; perhaps of the artist's father. Collection of Murray Louis, New York, NY.

## Biographical Sketches

**Mrs. E. T. Cockcroft, Riding Danger**, before 1916 (page 48 )

Mr. and Mrs. Edward Tilden Cockcroft (Viola A. Baker) were listed in the 1921 *Social Register of New York*. They resided at 130 E. 67th Street in New York and belonged to the Metropolitan and Colony clubs.

*Mrs. E. T. Cockcroft, Riding Danger,* was exhibited at the Ralston Galleries, 567 Fifth Avenue, New York, NY, and was published in 1917 in Grace Newton's book *A Hunting Alphabet: The ABC of Drag Hunting.* The painting, made between 1910 and 1916, illustrated the letter "A." The present location of this canvas, and of a second portrait of Mrs. Cockcroft shown at Ralston, is not known.

**Dr. Howard D. Collins, Riding Brisk**, 1914 (page 41)
**Dr. Howard Collins, MFH**, c 1929 (page 63)

Howard D. Collins (1868-1947) was born in New York. His forebears were ship owners and cotton merchants in Rhode Island and New York. After graduating from Yale and Columbia College of Physicians and Surgeons, he practiced in New York from 1896 until going abroad in 1917 as a field surgeon with the American Expeditionary Force.

Westchester County, NY, is the setting of Newton's 1914 portrait of *Dr. Howard D. Collins, MFH, Riding Brisk.* The 46-year-old Dr. Collins had a country property in Mt. Kisco, NY, where he hunted regularly until he moved to Millbrook in 1927. Brisk is said to have previously been one of the well-bred Vanderbilt grays. His docked tail indicates his use as a coach horse.

Around 1929, Newton painted another nearly full-length studio portrait of Dr. Collins, the newly elected MFH of the Millbrook Hounds, for the Riding Club in New York. After the club dissolved in the 1930's, the painting disappeared from view. It was noticed in a New York gallery in the 1950's and purchased by Dr. Collins' son, who had it trimmed to a more manageable size and inscribed with a facsimile of the artist's signature. Newton's original signature was later discovered on a small piece of identical canvas that had been tucked inside the frame's backing board when it was trimmed.

Dr. Collins also owned a Newton photo-lithograph published by David Ashley, Inc., Yonkers, NY. Mr. Newton signed and titled it "Foxy Quillet." On the back of the frame the artist wrote, "Dr. Howard D. Collins, 50 West 55th Street—From one who loves a gray to one who has a good one!" The painting

was also published in Grace Newton's 1917 book of poems *A Hunting Alphabet: The ABC of Drag Hunting* with the title "A Hunting Morn" as an illustration for the letter "P." The location of the canvas is not known.

Prior to World War I, Dr. Collins hunted part of every season in Millbrook when Oakleigh Thorne was master. In 1927, when MFH Thorne decided to give up his private pack, Dr. Collins became one of the hunt's incorporators and served as its master for six years, from 1929 to 1935. His son, Hugh Gawtry Collins, was master from 1964 to 1975, and his grandson, Farnham F. Collins, has served as Millbrook's MFH since 1978.

*Bermuda,* an undated landscape, is another Newton canvas that Dr. Collins owned. His grandson Farnham recalls, "My grandparents spent part of many summers in Bermuda....Mr. Newton visited them one year, at least, and painted this seascape."

### *Joseph E. Davis, MFH*, 1911(page 40)

Joseph E. Davis (1878-1955) was born in Piedmont, WV, to Mr. and Mrs. William R. Davis (Mary Tilliston). He was a nephew of Henry Gassaway Davis, a United States senator from West Virginia and an unsuccessful nominee for vice president in 1904. J. E. Davis was MFH of the Meadow Brook Hounds, one of America's most prominent hunts.

Established in 1880, the Meadow Brook Hounds merged with America's first drag pack, the Queens County Hounds, in 1893. The club began hunting a live fox in 1896 and was recognized by the National Steeplechase and Hunt Association in 1903. During the mastership of Joseph E. Davis (1910-1913), both drag and live hunting flourished. MFH Davis steadily built and occasionally hunted the Meadow Brook pack. His tenure included the hiring, in 1910, of a professional huntsman, Thomas Allison, who served for 41 seasons, from 1910 to 1951; the purchase in 1912 of Allison's pack of American hounds; the purchase in 1913 of Harry Worcester Smith's Grafton Hounds; and the development of a crossbred pack by breeding American dogs to English bitches. Davis hosted the Long Island hunting sojourns of the Green Spring Valley Hunt, MD, and the Middlesex Hunt, MA.

After graduating from Yale in 1900, Mr. Davis became director of the Island Creek Coal Company, the Pond Creek Pocahontas Company and the Blaine Coal Mining Company. During World War I, he served as an Army captain in France. He was a member of the Meadow Brook Club, the Piping Rock Club, the Coaching Club of America, the Palmetto Golf Club in Aiken, SC, and the Turf and Field, Racquet and

Tennis, Links and Recess clubs in New York. Davis' green and black racing silks often graced a winner. As an owner-rider, breeder and expert, Davis actively promoted the sport. He served as secretary-treasurer of the Jockey Club from 1941 to 1953, and as a steward from 1922 to 1954; and was also president of the National Steeplechase and Hunt Association.

Mr. Davis was married to the former Mary Carlton Maxwell, who, in addition to being a championship bridge and tennis player, was a very keen foxhunter. The Davises resided at 16 E. 72nd Street in New York. Mrs. Davis was a founder of the River Club and a vice-president of the Colony Club.

In 1955, at age 77, Joseph E. Davis died at his Long Island estate, Heyday House, in Upper Brookville, NY. Mrs. Davis continued to live there until her death in 1968.

Richard Newton's portrait, *Joseph E. Davis, MFH*, 1911, was published as the illustration to the letter 'E' in Grace Newton's *A Hunting Alphabet: The ABC of Drag Hunting*, 1917. Mrs. Davis also took artistic inspiration from the hunt field. In 1933 she wrote a series of verses for a *Hunting Calendar*, in which she captured the A to Z of foxhunting. For example:

*F is for Fence*
*And also for Fright*
*With which a Fence fills you*
*When nothing's gone right.*

*Y is for YAP*
*Who never will yield*
*A yard of his gap*
*To those new in the field.*

### Rufus C. Finch, MFH of the Watchung Hunt, before 1916

Rufus Finch was Master of the Watchung Hunt from 1910 to 1918. Founded in 1902 in the northern part of Middlesex County around Plainfield, NJ, by Dr. Middleton O'Malley Knott (the subject of the foxhunting saga *Gone Away with O'Malley*), by 1908 the club included over one hundred members.

In 1917, the Monmouth County Hunt, Eatontown, NJ, made Rufus Finch honorary huntsman. The following season, Finch was named MFH of the Monmouth County Hunt, a position he held until

1933. He helped to develop the club's two packs of hounds, which hunted six days a week: the drag hounds on Monday, Thursday and Saturday, and the foxhounds on Tuesday, Wednesday and Friday.

Mr. Newton no doubt knew Rufus Finch from his own early hunting association with the Monmouth Hunt. In 1891, P. F. Collier, MFH, hunted the Monmouth County, then a private pack in East Hampton. Newton noted in his 1935 article in *The East Hampton Star* that "when he departed for Newport, Mr. Collier transferred his hunting rights to Mr. Newton, who has held them ever since."

Mr. Rufus C. Finch and his wife, the former Adelaide B. Gardner, were listed in the 1919 *Social Register of New York* as residing at 31 W. 12th Street, NY. Their clubs were the Riding, Union League, Rumson Country and NY Athletic; he was also a member of the Sons of the Revolution.

*Rufus C. Finch, MFH of the Watchung Hunt,* was exhibited in 1916 at the Ralston Galleries, 567 Fifth Avenue, NY. The present location of the work, painted between 1910 and 1916, is not known.

### Robert L. Gerry, 1906 (page 36) and Miss Cornelia Harriman (Mrs. Gerry), 1907 (page 35)

Robert Livingston Gerry and Cornelia Harriman were married in 1908. Miss Harriman was the only daughter of the railroad magnate E. H. Harriman. Among Mr. Gerry's antecedents were Elbridge Gerry, a signer of the Declaration of Independence, governor of Massachusetts and vice-president under James Madison; and Robert Livingston, who, under the Hardenburgh Patent, was in 1707 granted 500,000 acres in New York State.

Robert L. Gerry's business interests included the Gerry Estates, Inc., several New York banks and the Oregon Railroad and Navigation Co. The couple lived in New York on East 79th Street and in Delaware County, NY. Aknusti, their 2,000-acre estate, featured a Georgian residence designed in 1912 by the Olmstead Brothers, the firm founded in 1898 by John Charles Olmstead (1852-1920) and Frederick Law Olmstead, Jr. (1870-1957), the stepson and son, respectively, of the famous architect and landscape-designer, Frederick Law Olmstead, Sr.

In addition to sitting for equestrian portraits before their marriage, the couple also owned two of Mr. Newton's portraits of American foxhounds, *Orange County Ranta* and *Orange County Stafford '99*, which, according to Mackay-Smith's epic text, *The American Foxhound*, were commissioned by the hunt's MFH, John R. Townsend. Mr. Gerry, as one the hunt's leading horsemen, also appears in Newton's *Orange County Hunt*, 1906. The canvas was destroyed in a fire at the Orange County Hunt's clubhouse in The Plains VA, in 1968. Also featured in the open-air foxhunting portrait were Mr. Gerry's father-in-law, E. H. Harriman, and Peter G. Gerry, John R. Townsend, MFH, and A.F. Bradley

### Mrs. Helen Buchanan Jones, Riding Katydid, 1917 (page 44)

In 1913, General and Mrs. James A. Buchanan built Ayshire, their country house in Upperville, VA. In 1917, they commissioned an oil portrait of their daughter, Helen (1888-1980), the only girl among their five children. Newton often produced double portraits. In this canvas, Helen, considered "one of the best and most widely known horsewomen in America," as reported on May 13, 1916, in *The Rider and Driver*, is riding Katydid. The General was fond of saying that the horse "won from Montreal to Upperville."

*The East Hampton Star* reported on August 8, 1915, in an article titled "Hunt Club Show," that Helen Buchanan had competed on Katydid at Mr. Newton's hunt and won a third-place ribbon.

Helen Buchanan was married to Walter McKay Jones. The couple spent winters in Puerto Rico overseeing his coffee plantations and during the balance of the year resided at Ayshire. When she was a child, Helen's father had been assigned to the island, where Fort Buchanan is named in his honor.

### Miss Catherine Louise Littauer, Riding Shawinigan, 1914 (page 42)

The portrait of Catherine Louise Littauer was likely commissioned by her parents, Col. and Mrs. William Littauer of Geneseo, NY. Miss Littauer's father was, according to magazines of the period, "prominent in racing circles," and Catherine surely became a skilled equestrian at an early age. The painting of the skewbald Shawinigan, three times Grand Champion, and young Miss Littauer riding sidesaddle, was listed in the 1976 Fauquier County, VA, Bicentennial Smithsonian Institution Survey.

In 1914, Richard Newton, Jr., possibly accompanied by his brother Francis, who was also known to have hunted with the Genesee Valley Hounds, traveled north toward Rochester, perhaps on the overnight train from New York City, to paint the open-air portrait of Catherine and her distinctive spotted championship horse.

The following year, 1915, Newton returned to the valley to produce another portrait, *Major W. Austin Wadsworth, MFH, Riding Devilkin,* which was presented by the field on the 35th anniversary of his mastership of the Genesee Valley Hunt. And on this same trip he was commissioned by the master to paint a portrait of his only child, *William P. Wadsworth, Riding a Hinny with a Lone Hound.*

In the early 1920's, Miss Catherine Littauer married Col. William E. Doeller of Virginia. The couple purchased Prospect Hill, originally built in 1811 by Chief Justice John Marshall for his son. The Queen Anne style home in Orlean, VA, overlooking the Blue Ridge Mountains, burned down in 1933 and was rebuilt in 1936. Mrs. Doeller's grandson surmises that the painting must have been in her parents' New York home at the time of the fire.

On October 7, 1972, after an extensive European trip, Mrs. Doeller died unexpectedly in London. She was a member of the Colony Club of New York, the Sulgrave Club of Washington, and the National Society of Colonial Dames of America. During World War II, Mrs. Doeller lived in Washington and, according to her obituary, "was active in many forms of war work."

Her husband, Col. William Eldon Doeller, was master of the Old Dominion Hounds from 1930 to 1940, and again after WW II from 1946 to 1949. During WW II he spent three years with the allied Air Force Intelligence Center in the South Pacific. Upon his return he worked in the Pentagon and retired as a lieutenant colonel in 1946. During WW I he served in the Field Artillery and until 1922 was in the Office of the Chief of Field Artillery. At his death at age 75 in Warrenton, VA, Colonel Doeller was a member of numerous international clubs: the Metropolitan in Washington; the Dunes in Narragansett, RI; Bucks in London; the Knickerbocker and River in New York; the Travelers in Paris; and Schloss Mittersill in Mittersill, Austria.

Newton's 1914 double portrait, *Miss Catherine Louise Littauer, Riding Shawinigan,* hangs in the dining room of de Forest, an estate adjacent to Prospect Hill, created on property belonging to the farm as the home of the Doellers' only child, William.

### *James K. Maddux, MFH, Riding Shining Light*, 1908 (page 33)

James K. Maddux (1853-1930) of Warrenton, VA, favored the American hound in his private pack, Mr. Maddux's Hounds. Between 1888 and 1910, he hunted his own hounds and kenneled them at his estate, Neptune Lodge. The National Hunt and Steeplechase Association recognized the pack in 1904. Maddux re-named the property, which was built c. 1845 and formerly known as Monte Rosa, after his horse Neptune, a famous hunter and chaser. Major General Billy Smith, the estate's former owner, was governor of Virginia for two terms, beginning in 1846 and in 1864. The farm was a stagecoach relay point on the line from Washington, DC, to Milledgeville, GA.

Born in Marshall, VA, on July 22, 1853, James Kerfoot Maddux was nine years old at the outbreak of the Civil War. At age 83, on October 21, 1930, he died of a heart attack at home.

In 1908, Richard Newton traveled to Virginia to paint the portrait of the 55-year-old MFH in Warrenton hunt country. The painting is on loan to the Museum of Hounds and Hunting from the family of Mr. Maddux's late grandniece, Mrs. William E. Howland.

*Mr. Maddux's Hounds* were well established when the sporting authors Higginson and Chamberlain wrote, "fields have increased, from twenty to twenty-five on average, while on special occasions many

more follow, none of them being keener or going better than Mrs. Maddux, the wife of the Master, who hunts not only with her husband's pack, but also with the Warrenton drag."

James Maddux was elected the first MFH of the Warrenton Hunt, serving terms in1887-1895, 1905-1906 and 1909-1910. His hunting career included 23 years as huntsman and 33 as master. Warrenton Hunt records show a club expense of $75.00 paid to J. K. Maddux on April 4, 1906, as the winner of an open race. Mr. Maddux was a formidable sportsman, to which attests the size of the prize, as compared with the club's annual dues at the time of $10.00. Maddux's keen interest in promoting horse sports led him to found the Virginia Gold Cup Race. He was one of the three judges in the great two-week, 12-hunt trial meet known as the American-English Foxhound Challenge. The two other judges were H. L. Mounius, MFH, Genesee Valley Hunt, and Dr. Charles McEachrand, MFH, Montreal Hunt. They decided that Harry W. Smith's American hounds "had done the best to work with the objective of killing the fox in full view." The challenger and owner of the English pack, A. Henry Higginson, forfeited the $1,000 purse. On November 15, 1905, the Dulany family estate of Welbourne in Middleburg, VA, was the scene of great celebration for all but Mr. Higginson, who was absent. Jim Maddux often delighted in recounting how he talked his friend Sam Riddle into placing a successful bid on a big chestnut colt consigned by August Belmont at the 1918 Saratoga Yearling Sale. The name of this soon-to-be famous colt was Man o' War.

### *Mrs. James K. Maddux, Riding Grey Cap*, 1908 (page 34)

The canvas portraying Mrs. James K. Maddux, the former Mae Muurling, was exactly the same size as that of her husband. They were likely displayed as a pair in the couple's Virginia home, which was often the location of famous parties. In her "Happenings" column in *The Fauquier Democrat*, Louise B. Evans wrote, "There were dinner parties and dinner parties, but none ever surpassed the Maddux's parties at 'Neptune Lodge'."

Mrs. Maddux was from a wealthy Dutch family who bought Leeton Hall next door to Mr. Maddux's Neptune Lodge in Warrenton, VA. The couple had one daughter, Winifred Maddux. In 1922, Mrs. Maddux's horse Oracle II won The Maryland Hunt Cup. The jockey was Lt. Raymond Belmont, who later married Mrs. Maddux. Following their divorce, she was married a third time, to Arthur White, who was given charge of her horses.

Last seen in an auction brochure for the Chicago Art Gallery, Inc., in 1968, the present location of *Mrs. James K. Maddux, Riding Grey Cap*, is not known.

**_Benjamin Nicoll, Esq., Essex Hunt, Riding Cocktail_** , before 1917 (page 49)

Benjamin Nicoll played in the 1st polo game on Long Island in 1877. The sport was introduced to America at a match in Westchester, on May 13, 1876, by James Gordon Bennett. Among Nicoll's Meadowbrook teammates were August Belmont, Thomas Hitchcock, Sr., and Oliver W. Bird.

Twenty-four years later, in 1900, Richard Newton, Jr., commented on the capabilities of the Meadowbrook's "leading American players" in his article, "The Glorious Sport of Polo," among them player No.4: "Benjamin Nicoll plays 'back' guarding the goal posts. He is a superbly built man, and rides at more weight than any man in the association. He is a safe hitter and a dangerous man to ride off, and is not excelled in his position." Newton earlier described "riding off" as a player "crowding his nearest opponent away from the ball, and giving his own nearest team man a clear chance at it."

Benjamin Nicoll was listed in the 1921 _Social Register of New York._ He was married to the former Grace Lord and resided at 46 W. 54th Street in New York. Their clubs were listed as: University, Racquet & Tennis, National Golf Links, Riding, Morris County Golf, Essex Fox Hounds, New York Yacht, Whippany River, Colony and The St. Nicholas Society. Mr. Nicoll graduated from Princeton in 1877.

Newton's oil portrait _Benjamin Nicoll, Esq., Essex Hunt, Riding Cocktail,_ was published in1917 in _A Hunting Alphabet: The ABC of Drag Hunting,_ a book of poems written by the painter's wife, Grace Newton as the illustration to the poem for the letter "C."

_C is the Casualty frequently met_
_When a Ditch next a creeper-clad fence lies_
_concealed;_

_Also the Comments of most of the field,_
_"For the man who lays drags with a butter-_
_fly net!"_

**_Reginald Rives_**, 1931 (page 64)

Reginald (Regie) William Rives (1862-1948) was well known as a leader in the sport of road coaching and served as president of the Coaching Club, which his father, Francis Robert Rives, had helped found in 1875 along with his famous contemporaries August Belmont, Alfred G. Vanderbilt, James R. Roosevelt

and others. The club took its inspiration from England, where the sport of coaching was enjoying a revival.

In 1883, as a 21-year-old whip, Reginald Rives was elected to the Coaching Club, where he furthered the sport of four-in-hand driving in America. According to his obituary in the *New York Tribune*, the "days of coaching ended officially in New York" in 1910, "when Mr. Rives, then vice-president of the Coaching Club, announced that the mechanical age of the automobile had forced the coach off city streets and rural highways, dooming any further progress of the sport." That same year he organized one of the most notable social events of the era, a parade of coaches up Fifth Avenue and through Central Park. He became the club's president in 1933 and two years later compiled the definitive book on the vanished sport, *The Coaching Club, Its History and Activities*.

Mr. Rives was no doubt a friend of Richard Newton, who was also a keen whip and drove one of the last four-in-hand coaches well into the 1930's in Southampton, NY. Newton's pastime required that the trees be especially cut along the country roads so that the coach, with his entourage riding on top of the lofty vehicle pulled by four high-stepping horses, could pass safely under the branches.

Newton's portrait of Reginald Rives hangs at present in New York's Knickerbocker Club. It was published in 1967 in *American Heritage* in an article with the apposite title "When the Coachman was a Millionaire." His obituary reported that "Mr. Rives was whip of the public coach Pioneer for nine years. Each spring he drove the coach from the Holland House, at Fifth Avenue and Twenty-ninth Street, to Ardsley, N.Y., and he once said that he was never more than forty-five seconds late on the two-and-one-half-hour, twenty-one-mile trip."

Mr. Rives was born in New York City in 1861and lived most of his life in Wappinger Falls, NY, at Carnwath, his family's Dutchess County estate, where he developed a successful farm business and established one of the finest stables of harness and saddle horses in America. Educated at St. Paul's in Concord, NH, and Columbia Law School (1883), Mr. Rives was admitted to the bar in 1887. He was much sought after as a horse show judge from 1910 to 1935 and was secretary-treasurer and general manager of the National Horse Show from 1925 to 1935.

According to his great-grandnephew Barclay Rives, young Regie, when still too small to manage a pony team, was given a pair of goats that he trained to drive tandem. Throughout his life, Rives turned this early training to his advantage, often winning wagers by successfully performing seemingly impossible coaching maneuvers. On one occasion he proved a senior member of the club wrong by turning his coach around in the narrow courtyard of the Metropolitan Club without even slowing from a trot, let alone stopping and backing up, winning not only accolades but dinner for nine and a side bet of $50.

Mr. Rives was a member of the Union and Knickerbocker clubs. His first marriage, to Mary C. Buckley, ended in divorce in 1912, and the following year he married Mrs. Elizabeth Struthers Taylor. He died at 86, on February 18, 1948, in New York, at the Hotel Ambassador, Park Avenue and 51st Street, where he made his home. Mr. Newton in this period was also a resident of the Ambassador when he was not living at his country home and studio, Box Farm, in Water Mill, NY.

### *Rock Sand*, 1911 (page 43)

The winner of the English Triple Crown in 1903, the dark bay/brown colt Rock Sand (1900-1914) was brought to America in 1906 by August Belmont, Jr., who purchased him from the estate of Sir James Miller's Hamilton Stud in Newmarket for £ 25,000 ($125,000). Sir Miller purchased the colt's dam, Roquebrune, in 1894 as a yearling for 4,100 guineas ($21,000), in a dispersal sale of the Duchess of Montrose's estate. In that same sale Miller also purchased Rock Sand's sire, Saifoin, who later won the Derby.

In his lifetime Rock Sand raced for $232,000 and won sixteen of his twenty starts, placed once and showed three times. The 15.3-hand colt, considered temperamental by trainers, never finished a race in less than third place.

Racing injuries as a two-year-old led to his retirement at Hamilton Stud in the spring of 1905, where he was put to only a few mares before being sold to Belmont's famous Nursery Stud. After six breeding seasons, following the racing blackout of 1911 and 1912, he was sold to a syndicate of wealthy Americans who were sending their stallions overseas. Rock Sand was shipped to France, where after one season, on the eve of WWI, he died of heart disease on June 20, 1914.

Chief among Rock Sand's progeny is his famous grandson out of his daughter Mahubah (1910) by Fair Play (1905), Man o' War (1917). Mrs. Belmont had named the foal My Man o' War in tribute to her husband, who was serving in France during WW I. Mr. Belmont later disbanded the stable and, after dropping the proprietary pronoun from the colt's name, sold it to Glen Riddle Farm in Maryland. (An additional reference to Man o' War can be found in the biographical sketch about J. K. Maddux.)

### *Daniel Cox Sands, MFH of the Middleburg and Piedmont Hunt*, 1920 (page 52)

Daniel Cox Sands (1875-1963) is portrayed by Newton with a distinctive American element, the cow horn, which many Southerners favored over the traditional English copper or silver horn. Dan Sands served as a master of foxhounds for 44 years. He rode with the Piedmont Hunt from 1909 to 1915, and simultaneously, from

1912 to 1915, he was MFH of the Middleburg Hunt. From 1917 to 1919, he served as Middleburg's acting MFH, and later became the hunt's master from 1921 to 1954.

The only son of Quaker parents, Sands was born on November 22, 1875, in New York City. As a boy, he lived in the city and on the family farm in Westchester County, NY. In 1907, he purchased Benton in Middleburg, VA. He died in Middleburg on May 10, 1963, at the age of 88. Mrs. Sands died in 1948 in a car accident. She was the former Edith Kennedy of Southampton, NY, and may have known Mr. Newton from girlhood. In addition to being the president of the Garden Club of Virginia, Mrs. Sands was noted for being a grand hostess, an avid beagler and civic leader.

At Benton, Mr. Sands bred racehorses and developed a herd of Guernsey prizewinners. The Sands' four stock farms and one dairy employed 35 people in the midst of the Depression. Running the household required seven servants—Mrs. Sands' maid, Mr. Sands' valet, a parlor maid, a pantry boy, two cooks and a chauffeur.

Fondly known as "Mr. Middleburg," Dan Sands founded the American Foxhound Club in 1912 and the Middleburg Bank in 1924. He sponsored the first steeplechase of modern times at Mount Defiance in 1911 and developed the Glenwood Park racecourse on his estate in 1932. He served on the Loudoun County Board of Supervisors, and was a director of the Loudoun Hospital Center and president of the Middleburg Community Center.

The 1918 hunt diary of John B. Anderson includes numerous entries mentioning MFH Sands. Mr. Sands wrote a brief history of foxhunting for a special issue of *The Loudoun Times*, June 1922. Commenting on the sport's American roots, he noted that "General Washington was given several couples of hounds by General Lafayette." The article concludes with the avowal that "I have Loudoun County to thank for the greatest days sport and pleasure I have ever known."

Reminiscing in 1978, Mrs. Neville L. Atkinson recalled teaching Mr. Sands the art of hunting: "I lived at Welbourne and started to ride to hounds with my uncle, Dick Dulany, in 1905. When Mr. Sands decided to try hunting some years later, I felt I was an old hand at the game, and he came out with me on his first hunt. He was absolutely thrilled by it, and was perfectly undaunted by numerous spills; until he learned how to cope with galloping over uneven ground and facing a great variety of obstacles it was necessary to jump in order to stay with hounds. He became one of the best at finding his way across country, with unlimited nerve, a hard man to stay with."

Mrs. Atkinson painted her own—verbal—picture of Sands at the traditional Thanksgiving meet: "When Miss Charlotte Noland's School for girls, 'Foxcroft,' got into full stride, the girls provided the choir for the

Episcopal Church in Middleburg. Miss Charlotte invited Mr. Sands to hold the Thanksgiving Day meet on the lawn at Foxcroft and invited the field to return for a hunt breakfast. … [T]hose wishing to hunt came to the service dressed in hunting clothes. Mr. Sands in his scarlet coat, white breeks and top boots always took up the collection."

Mrs. Atkinson also composed a verse to honor the master:

> *He was always with hounds, in spite of their speed:*
> *No fence was too high and he gave us a lead.*

### Miss Jean Browne Scott, Driving Newton Victor, 1926 (page 61)

Jean Browne Scott (1903-1990) was the only daughter of John R. K. Scott and Helen Tennant Hardie of Valley Forge and Philadelphia, PA. Their country estate was known as Glenhardie. In 1930, Miss Scott married D. Weston Darby and left the world of championship horses that Mr. Newton had documented for her.

From a young age, Miss Scott displayed a fondness for horses and by age 11 was a blue ribbon winner in the show ring. She achieved world-renown in the carriage and coaching world in her early 20's. In 1924, 1925 and 1926 she won the English championship for hackney horses. She also won numerous hackney championships in America for five consecutive years, 1923-1927.

Newton's first portrait of Miss Scott, as a girl of 23, was painted in 1926 and depicts her stylish phaeton coach and champion horse, Newton Victor. The horse was purchased in Europe in 1924 by her trainer, Paddy O' Connell, who was described by the *Coaching Journal* in 1988 as "shrewd enough to realize that his young protégée needed a mature and experienced horse if she was to move quickly to the top." With his Irish brogue, Paddy convinced Madame Drory de Perez of Holland to sell him two impeccable and talented horses, Newton Victor and Fairview Leader. Earlier in this same European horse-shopping trip, at the Hackney Society's show in Doncaster, Yorkshire, Paddy had secured the purchase of Knight Commander, a talented horse at the top of his form with four winning seasons in England and Holland.

In 1921, as an ambitious 21-year-old, Miss Scott made her show debut in England at the Royal Richmond and followed her success there at the International Show held at Olympia. *The Carriage Journal* in 1988 recalled that Miss Scott's performance at Olympia was noticed by Geoffery Bennett, "the leading Hackney critic of the day," who reported the following in the *Livestock Journal*: "One of the most charming sights of the show was Miss Scott driving her chestnuts, Newton Victor and Fairview Leader, in the class for pairs to be driven by

amateurs. The two are exactly of a type, both in looks and action. They are perfect models of what a Hackney should be; compact, breedy horses which bridle beautifully and trot right on with great freedom and éclat. Miss Scott handled them magnificently, settling her horses and getting in a dash before the judges like a veteran professional, receiving a fine ovation from a large and enthusiastic audience."

The Scott stables were continually expanded until 1927 with world-class proven winners. From the Scottish ship-owner W. S. Miller they acquired the acclaimed Glenavon Charm, Knight Templar and Knight Errant. As with the earlier purchases, Mr. Scott's cables from America were persuasive and no doubt quite substantial. Miss Scott worked hard and proved herself a talented whip. In addition to Newton's pictures, her collection of trophies, several presented to her by King George V, remains as a tangible reminder of her achievements.

### Oakleigh Thorne, MFH, 1917 (page 50)

Oakleigh Thorne (1866-1948), the youngest of three sons, was born in 1866 to Mr. and Mrs. Edwin Thorne, of Millbrook, NY. His mother died shortly after his birth and his father, a prosperous Quaker farmer, became a major influence in his upbringing. Oakleigh Thorne loved the outdoors, and it was said that he knew the country from Smithfield to Tyrell Lake intimately, having trapped, fished and shot over it like no man in Millbrook. By 1889, Thorne had met and married Helen Stafford, his lifelong love. They had two daughters and lived at Thornedale in Millbrook, wintering at their Briarcliff Farm in Santa Barbara, CA.

Thorne established his private pack in 1910, after Charles C. Marshall, who founded the hunt in 1907, gave it up for financial reasons. To a large degree the enthusiasm of Margaret Thorne, the master's daughter, added to her father's interest in the sport. In 1912, she married Edward H. Carle. While they were on their honeymoon in England, Mr. Thorne telegrammed the new couple to request that they buy a pack of harriers. They selected and purchased a made pack from Henry Hawkins and also secured a new English huntsman, Harry Knott, formerly of Epping Forest.

A plaque on the frame of Newton's portrait, *Oakleigh Thorne, MFH,* 1917, illustrates the great esteem that the members of the hunt field had for their master, who served from 1910 to1928. It reads: "Presented to Oakleigh Thorne, MFH, by the residents of Millbrook in appreciation of his devoted efforts in making Millbrook a hunting country."

According to the master's great-grandson Oakleigh Thorne, for a period of ten years he put $50,000 a year into paneling and developing the Millbrook hunt country. Today his generosity, half-a-million dollars' worth, is still evident to anyone fortunate enough to enjoy a day out with this pre-eminent club.

Mr. Thorne's portrait was Newton's second commission to be paid for by members of an appreciative hunt field, following the 1915 portrait of Major Wadsworth. In contrast with the earlier painting, which portrays hounds at rest, the Millbrook hounds are in full cry. *Oakleigh Thorne, MFH*, was published in *A Hunting Alphabet: The ABC of Drag Hunting* by Grace Newton, 1917, as an illustration for the letter "Y."

In this era of prosperity, ardent foxhunters built many of Millbrook's great estates. Between 1913 and 1919, A. H. Higginson, at MFH Thorne's request, hunted the country with his Middlesex Foxhounds. World War I brought tragedy home to the kennels: For the sake of home-front economy, Mr. Thorne put down forty good hounds. Many members of the field were in the service of their country, and in 1918 no hunt diary was kept. The hunt rebounded strongly after the war, but the era of the English hound at Millbrook ended abruptly when divorce caused Margaret Thorne Carle to lose her interest in hunting. Her father disbanded the pack and sent both his hounds and his huntsman to the Genesee Valley.

During the final five years of his mastership, 1923-1928, Mr. Thorne invited Joseph B. Thomas and his American hounds to hunt the Millbrook country from July to December. In 1929, Millbrook's next MFH, Dr. Howard D. Collins, also the subject of a Newton portrait, began his tenure.

### *John R. Townsend, MFH, Orange County Hunt*, 1906 (page 12)

John Townsend was a master of foxhounds for seventeen seasons, beginning with the Orange County Hunt from 1903 to 1908. Concurrently he was MFH of Middleburg, 1906-1908, and Piedmont, 1907-1908. He again served as MFH of Middleburg from 1910 to 1912, and later became MFH of the Glen Arden Hunt from 1911 to 1919.

Mr. Townsend was among the group of four New York City gentlemen who selected the town of Goshen in Orange County, NY, as a suitable site for keeping a pack of drag hounds. P. F. Collier, who hunted his own pack in Monmouth County, NJ, loaned ten couples of hounds, a huntsman, a whipper-in, a kennel man and six horses on which to mount the hunt staff—everything that was needed to start the Orange County Hunt. After a successful season in 1901, they purchased 25 couples of hounds in England and by 1903 had turned their attention to foxhunting. That year, Townsend was elected MFH. In an effort to extend their season, and in pursuit of better foxhunting territory, the club developed a new southern country at The Plains, Virginia. The 1908 foxhunting classic *Hunts of the United States and Canada* characterizes the MFH thusly: "Mr. Townsend, whose heart and soul is in the sport, has spent a great deal of time experimenting on the best type of hound for the country; in fact it was he who

offered…the trophy competed for in 1905, when the Middlesex and Grafton hounds held their memorable match," which tested the respective hunting skills of American and English hounds.

In 1906, in part to settle a territorial dispute with the MFH of the Grafton, Townsend and others formed the Middleburg Hunt. During his tenure, Orange County kept an English pack for drag hunting in Goshen, NY, and an American and crossbred pack at The Plains for foxhunting.

*John R. Townsend, Riding Greek Dollar,* is Newton's earliest known portrait commission. About this time he also painted *The Orange County Hunt*, a complex group portrait including MFH Townsend, 12½ couple of foxhounds, and five members of the hunt staff and their horses. A photograph of the painting copyrighted by A. F. Brady, NY, in 1906, was published in *Hunts of the United States and Canada.*

In 1964, Mrs. J. Van S. Bloodgood (Lida L. Fleitmann) donated Newton's portrait of Mr. Townsend to the Long Island Museum. On June 3, 1965, from the Palazzo Taverna, 36 Via Monte Giordano, Rome, she wrote to Ward Melville, the father of Mrs. James H. Blackwell, about Newton's 1940 portrait: "The Townsend portrait was transferred from the Inn to the Riding Club when J. R. Townsend resigned as MFH of the Glen Arden (Goshen) Hunt round about 1920. I shall anxiously await news as to the arrival of the portrait and your impression of it. The horse that J. R. T. is riding, 'Greek Dollar' by 'Dorian' out of 'Dare Dollar,' was one of the handsomest thoroughbreds I ever saw, but very hot tempered. Many people who have seen the portrait think it was one of Dickie Newton's best."

In her 1953 memoir, *Hoofs in the Distance*, Lida Fleitmann wrote vividly about her first day hunting with Mr. Newton's Suffolk Hounds and her girlhood admiration for Mr. Townsend. She too was portrayed by Newton riding her horse, Gypsie Queen; however, only a photograph and a small fragment of the painting remain.

*John R. Townsend, Riding Greek Dollar*, was published in *A Hunting Alphabet: The ABC of Drag Hunting*, written by the artist's wife, Grace Newton, as the illustration to her poem for the letter "E."

On October 20, 1923, *The Rider and Driver* published Mr. Townsend's obituary, noting that he was then the director of the National Horse Show Association and the donor of the John R. Townsend Trophy for indoor polo, a sport for which he was a "leading advocate." A 62-year-old retired stockbroker, he resided at 14 E. 60th St. in New York. His clubs included the Union and the Riding. The announcement further notes that "services were held in Grace Church Chantry and a large crowd of notable people of the social and horse world attended."

***Major W. Austin Wadsworth, MFH, Riding Devilkin**, 1915 (page 47)*

After moving west from Connecticut in1790, James and William Wadsworth established the village of Geneseo, NY, on a 60,000-acre tract. Their descendant Major William Austin Wadsworth (1847-1918), who became known as the "Dean of American Foxhunting," founded the Livingston County Hunt in 1876 and proceeded to make hunting history over the next 41 seasons, founding Major Wadsworth's Hounds and today's Genesee Valley Hunt. The family tradition continued as his son, William P. Wadsworth, "carried the horn" after the Major retired. The Major's grandchildren W. Austin and Martha D. Wadsworth are the current masters of the Genesee Valley Hounds.

In 1901, when he was 54, Major W. Austin Wadsworth married Elizabeth Greene Perkins (1870-1943) of Boston. This keen 31-year-old horsewoman transformed his estate, known as the Homestead, from a "bachelor's hall" to a showplace. Among the couple's guests were Mark Twain, William McKinley, Theodore Roosevelt and, in 1915, the painter Richard Newton, Jr.

Major Wadsworth wrote extensively about foxhunting. His hunt diaries are full of wit, sarcasm and humor. In *The Wadsworths of the Genesee*, its author, Alden Hatch, notes that the "master was a true philosopher of the chase," as evidenced by this entry in the Major's diary from October 21, 1880:

"Found in the gully and to Casino's farm and through his sheep, which got out and he stuck us ten dollars for it. Then through Oneida Woods where T. Carey, Doctor Young and some others wanted hounds lifted. This the M. F. H. refused to do upon which they became intemperate, rebellious and undisciplined in their language, causing the M. F. H. to halt and deliver a lecture on the science of foxhunting, and especially the great respect and reverence due all M. F. H.'s.

"By means of which noble lecture the fox escaped and finally got into a barnyard and killed a chicken and was knocked on the head by a farmer, who subsequently watched us search for him with pleasure, but kept mum, afterward sold the skin for a dollar seventy-five to pay for the chicken which might have been worth twenty-five cents.

"However, the hearers profited by their lecture and were improved, while the fox deserved to be killed for killing the chicken, and the chicken for tempting the fox, and the dogs to be disappointed for not working harder."

In 1915, Richard Newton traveled by rail from New York City to Geneseo to paint *Major W. Austin Wadsworth, MFH, Riding Devilkin.* The venerable Wadsworth was now 68 years old and would retire in two years and be dead in three. His devoted "field" commissioned the painting, as recorded on a plaque attached to the frame: "Presented by the Members of the Genesee Valley Hunt on the 35th Anniversary of his

Mastership, October 1915. In Grateful Acknowledgement of Many a Good Day." The painting is in the Wadsworth Homestead in Geneseo, NY.

Snow often comes early in Upstate New York, and it features in Newton's portrait of the Wadsworths' only child, *William P. Wadsworth, Riding a Hinny with a Lone Hound*, 1915. This winter scene still hangs in the Homestead, where Newton stayed while painting it. Of note is the hound in the painting: an exact replica appears in the painting of the Major. This would not be considered unusual, except that the same hound, with an identical white stripe on his flank, stern held proudly, and head cocked, looking up at these two sitters, is also in the 1911 portrait of Joseph E. Davis. Newton must have liked this hound's affectionate pose, recorded it in his sketch book or on film and, after using it in the Davis picture, found it an effective device for creating upward motion and copied it again, in these two paintings, four years later. The question remains whether a wise judge of hounds like the Major failed to notice that this hound was not from his own kennel.

In 1917, after a life of hunting and breeding hounds, a year before his death, Major Wadsworth stopped foxhunting and gave his hounds to the Millbrook Hunt. After WWI, the Genesee Valley Hunt resumed for a season but was then suspended. In 1922, a subscription pack was established and by 1933 William P. Wadsworth was master.

Mr. Newton's portrait, *Major W. Austin Wadsworth, MFH, Riding Devilkin*, 1915, was published as the illustration for the letter "S'" in Grace Newton's *A Hunting Alphabet: The ABC of Drag Hunting*, 1917.

*S is the scent, none too pleasant to those*
*Who ride not to hounds; but at swift hunting pace,*
*When the Right Sort detect it, how madly they race;*
*They find it more sweet than the scent of a rose.*

### William P. Wadsworth, Riding a Hinny with a Lone Hound, 1915 (page 45)

Affectionately known as "W.P." and widely regarded as an exceptional hound man, William Perkins Wadsworth (1906-1982) was huntsman and master of the Genesee Valley Hunt from 1932 to 1975, except for a brief interval during World War II when he served in France and Germany with the 101st Cavalry. Born on September 16, 1906, he was the only son of Major William Austin Wadsworth and the former Elizabeth Greene Perkins. Bill Wadsworth attended St. Paul's School in Concord, NH, and

Harvard University, and in 1929 he married Martha Doty Scofield. Following her death, in 1959 he married Penelope Weare Crane, a fellow foxhunter from Buffalo, NY.

Introduced to hunting at age six by his father, he soon had a beagle pack of his own. In Newton's 1915 portrait, 9-year-old Bill Wadsworth is riding a hinny (the result of a cross between a stallion and a female donkey) under a spreading oak, a characteristic aspect of the region's landscape. The Wadsworths' tenants were required to keep one oak for every fifty acres cleared.

Wadsworth's great-grandfather James Wadsworth and his brother William moved to Geneseo, NY, from Connecticut after the Revolutionary War and opened a vast tract of land south of Lake Ontario. Bill Wadsworth owned 30,000 acres upon his retirement from the U.S. Army as a lieutenant colonel after WW II. At his death, at age 74, he owned just less than 6,000 acres, having divided the original holdings among his four children.

In 1979, William P. Wadsworth was inducted into the Huntsmen's Room at the Museum of Hounds and Hunting, having served as master for 38 seasons and as huntsman for 28. He was president of the Masters of Foxhounds of America from 1970 to 1973, a position especially meaningful since his father had been the organization's first president in 1907. His stylish little book, *Riding to Hounds in America*, written in 1959, clarifies the fine points of every aspect of hunting and is in wide use today.

Members of the Genesee Valley Hunt, which was founded in 1876 on the centennial of the Revolution, sport unique attire. In a display of patriotism, traditional scarlet coats are eschewed in favor of dark blue melton coats, buff collars and buff breeches, the colors worn by the Continental Army.

The Wadsworth family is still writing hunt history. The hunt's current joint masters are Martha D. Wadsworth, granddaughter of Major Wadsworth, and Marion Thorne, stepdaughter of the Major's grandson, the recently retired joint master W. Austin Wadsworth. Marion Thorne is also the huntsman. In 2001, the crossbred pack of 36 couples went out 74 times, from August until Upstate New York's winter weather made hunting impossible.

# Photographic Credits

Peter A. Juley & Son. *Orange County Stafford '99* (J0118446), page 32; *Orange County Ranta* (J0011169), page 31; *Master Luther Tucker* (J0024488), page 50.

Howard Allen Studio, Middleburg, VA. *James K. Maddux, MFH, Riding Shining Light*, page 33; *The Pups "Meet," Heyday House Terriers*, page 38; *Joseph E. Davis, MFH*, page 40; *Dr. Howard D. Collins, MFH, Riding Brisk*, page 41; *Major W. Austin Wadsworth, Riding Devilkin*, page 47; *William P. Wadsworth, Riding a Hinny with a Lone Hound*, page 45; *Untitled (Hunter Barn)*, page 46, *Oakleigh Thorne, MFH*, page 50; *Mrs. Helen Buchanan Jones, Riding Katydid*, page 44; *Daniel Cox Sands, MFH of the Middleburg and Piedmont Hunt*, page 52; *Dr. Howard D. Collins, MFH*, page 63; *Portrait of a Racehorse and Jockey*, page 62; *Foxy Quillett*, page 51.

Arthur Liese, Pennington, NJ. *Thomas Allison Riding Pickles*, page 64.

John J. Head, Washington, VA. *Robert Livingston Gerry*, page 36; *Miss Cornelia Harriman*, page 35; *Catherine Louise Littauer, Riding Shawinigan*, page 42; *Untitled (Early Morning Stable Scene)*, page 59; *Untitled (Hunt Scene and a Farmer's Team)*, page 58; *Miss Jean Browne Scott, Driving Newton Victor*, page 61.

Alastair Finlay. *Rock Sand*, page 43.

# Appendix

## RIDING TO HOUNDS.

### BY RICHARD NEWTON, JR.

WHY MEN WHO "RIDE STRAIGHT" TO HOUNDS THINK THAT THEIRS IS THE KING OF OUTDOOR
SPORTS—THE STORY OF A TYPICAL DAY'S RUN ON LONG ISLAND,
TOLD WITH PEN AND CAMERA.

DURING the last twenty years or so, the sport of hunting—using the word in the only sense in which people who ride to hounds understand it—has grown, in the United States, from very modest beginnings among a few enthusiasts in New Jersey until today we have a long list of first rate packs of foxhounds, with well appointed clubhouses,

and the Elkridge and Deep Spring Valley Hunts in the South, are perhaps the best known.

Although those who ride to hounds are enthusiastic followers of the sport, it can never become a really popular one, as is golf or baseball. Besides its heavy demands upon the leisure of its devotees, if a man wants to ride twice or three times

WITH THE MEADOW BROOK HOUNDS—JUMPING ONE OF THE STIFF LONG ISLAND FENCES.
*From a photograph by John C. Hemment.*

kennels, and stables scattered all the way from Massachusetts to North Carolina. Besides many others that might be mentioned, the Myopia and Agawam near Boston, the Essex, Monmouth, and Ocean County Hounds in New Jersey, the Meadow Brook on Long Island, the Genesee Valley Hunt in New York, the Radnor and Rose Tree Hunts near Philadelphia, the Richmond of Staten Island,

7 M

a week during the hunting season, he must keep several hunters, and the expense is a severe tax upon any but a tolerably well filled purse.

In this country the majority of the runs are "drag hunts," on a scent laid by the "drag man" several hours before the run takes place. The drag is in vogue partly because foxes are scarce and it takes a long time to "find" them, and

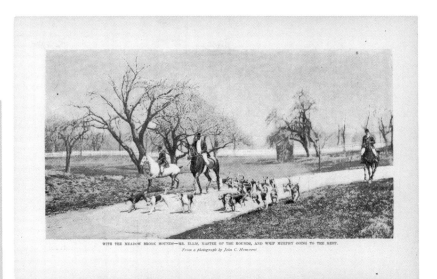

WITH THE MEADOW BROOK HOUNDS—MR. ELLIS, MASTER OF THE HOUNDS, AND WHIP MURPHY GOING TO THE MEET.
*From a photograph by John C. Hemment.*

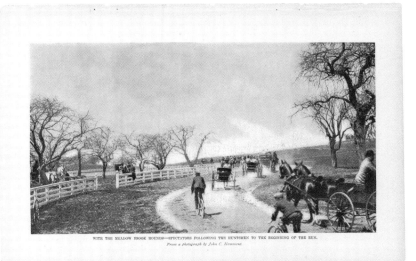

WITH THE MEADOW BROOK HOUNDS—SPECTATORS FOLLOWING THE HUNTSMEN TO THE BEGINNING OF THE RUN.
*From a photograph by John C. Hemment.*

partly because most men want a good gallop with plenty of fencing to make it exciting, and also to know that they will not spend perhaps a whole day in the saddle, only to have the fox escape them by taking to earth. At one of the best known clubs, however, two distinct packs are kept, one of imported English fox-hounds, exclusively for drag hunting, the other, native bred Virginia dogs, used for real foxes.

It was not so long ago when to make fun of drag hunting, and to deride people who followed a pack of dogs on the trail of an aniseed bag, was a favorite diversion of the newspaper humorist. Not a dozen years ago, the announcement of a meet was hailed with mockery and a pink coat held in wondering scorn, with the added sting of being called an "English fad." Now a fad is the transient amusement of the ennuyé individual who wants to do the "latest thing" correctly. It is true that the sport came to us from England, but what game save our own base-ball have we not borrowed? The development of hunting, and the persistence with which its devotees follow it through all weathers, prove the genuineness of their devotion and its merit as a sport. Not a few of our boldest and cleverest riders find in it a salutary change from active and arduous business life.

Drag hunting may require less skill on the part of the hounds, as the scent is laid through open country to get fast galloping, and the fencing hardly checks hounds at all; while a cunning fox will double and turn on his track, using every faculty with which his shrewd nature is endowed to elude his pursuers. But in no way does it lessen the test of nerve and skill on the part of the rider who follows "straight."

Hunting begins generally with the coming of October (when the crops have been harvested) and ends only when frost ruins the going—usually about the time of the Christmas holidays. Many of the clubs have a spring season of a month or six weeks, beginning in March, but this is more uncertain. Cards are issued in the autumn, announcing the time and place of meets for the month; but the schedule for the spring season often reads: "Weather permitting, hounds will meet at such and such a place."

In the beginning, a good many years

ago, the farmers looked askance at the "dudes from town" who came out by train or drove from their country places to the meet, and who often rode ruthlessly over the fields, frightening the cattle and perhaps breaking through some timber fence, instead of clearing it. Worse than any actual damage done to property, however, was the owner's wounded pride at the invaders' neglect to ask permission for their uninvited intrusion. Riders have been literally held up at fences by irate farmers, armed with pitchforks, and in righteous wrath bidding the hunters to "come on if they dared and get what they deserved," perhaps suggesting the days of '76, when the sturdy New England yeoman held at bay, with whatever weapon came first to hand, the redcoats who profaned his native soil. Others, less violent, might be heard threatening dire vengeance in the local courts upon the trespassers, with the wish expressed very audibly that "every ninny would break his blamed neck over the fences"; while panic stricken towheads would cling frantically to their mothers' skirts in kitchen dooryards, watching the hunt with as much awe as a stampede of real centaurs would cause.

But happily, through experience and wise judgment on the part of the "masters," right of way is now asked, and where not obtained farms are carefully avoided; broken rails are replaced the next day, and a "damage fund" is kept to repay owners for careless or unintentional riding over spring wheat, or the crushing of a row of cabbages. Moreover, the hunting set in any district brings a great deal of ready money to the natives by the purchase of their produce, to say nothing of the added value of real estate, which has often fairly jumped with the building of handsome homes and spacious stables near the different hunting centers. Nowadays, the small rusties wait to try to catch a glimpse of the drag man going by, just as eagerly as the city bred urchin follows a hand organ and monkey; while farmers and their farm hands, perched on haystacks, sheds, or any good points of vantage, watch the hunt as it dashes by, and cheer a particularly clever or showy jump made by a horse near them. The women, too, stop in their laborious duties and wave a sunbonnet, or call to the children to hurry and see.

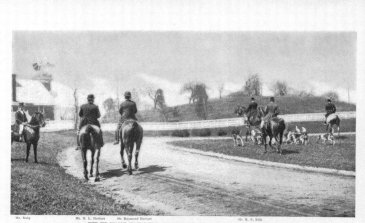

WITH THE MEADOW BROOK HOUNDS—LOOKING FOR THE TRAIL AT THE BEGINNING OF THE RUN.

From a photograph by John C. Hemment.

And after the run is over, and steeds and riders are "hacking home," teamsters will often draw up their horses, and, dropping their usual reserve of manner toward all city bred people, will ask with real interest if the fox was caught. For although, as has been said, most of the runs are drags, very often a live fox is liberated at the end, or with the last "check," and hounds will readily change

from the artificial to the real scent. The dogs give tongue gaily as the scent becomes stronger, and the fox often breaks cover and runs in the open until "he is caught—or perhaps till he takes to earth, if he knows the country, or eludes his pursuers by crossing water.

In a day's sport there often occur funny and amusing incidents that can be laughed over afterwards at the dinner table. One day, out with the Essex, hounds were running very fast and giving tongue freely through a beautiful open field, towards the edge of a wood, where a very small and very fat young Jerseyman, having strayed out to gather acorns, was suddenly nearly scared out of his diminutive wits by a large pack in full cry passing directly in his path, followed by horses and strangely dressed men, who came thundering along and almost rode him down before he was seen. In sheer desperation he frantically tried

to climb the first tree, but the nearest being a large one, and his legs and arms extremely short, he only succeeded in partially clasping the trunk; and there he hung, his little fat legs tucked up under him, hardly a foot from the ground, and his little fingers holding on by clawing the bark. With such frantic shrieks did he rend the air that some riders on a near by road, concluding that a murder

WITH THE MEADOW BROOK HOUNDS—WHIP MURPHY AT THE KILL.

From a Photograph by John C. Hemment.

was taking place, gave up the chase, and scrambling over to the woods, hastened to aid the luckless urchin. But at each word of comfort and kindly assurance he would only yell the louder, as if to show his utter distrust of all mankind. A farmer, being also attracted by the disturbance, came up and told the would be rescuers to go along and never mind, as the small boy "would come down when he was ready." As this seemed to be the only solution of the problem, the riders started off to make up for lost time, perhaps luckily to meet the hounds crossing the road somewhere ahead, or to find them at the next "check." A little further down the road, some country women, who were asked if they had seen anything of the pack going by, drawled out that "they didn't know anything about any hounds, but a circus had gone by through the fields about fifteen minutes before."

Another time, near the same locality,

hounds had faltered and gone astray in the scent and were very carefully but fruitlessly working a small swamp, closely adjoining a farm house, while the master, whips, and riders were slopping around in the thick, black New Jersey mud, doing their best to cheer and encourage the dogs. An old woman leaning in the doorway close by soliloquized very audibly for the benefit of all concerned that in her sixty years of life there she had seen most every kind of "critter" in that swamp, "but it did beat all to see a lot of fellers in red coats, white pants, and silk hats slopping around in that bog in the steady rain, looking for pollywogs, for all she knew."

With the Essex hounds in New Jersey there is to be found a beautiful stretch of country, with limitless possibilities for new runs over the rolling hills covered with peach and apple orchards, up hill and down dale, through wide meadows, over clean fencing and flying small brooks, with many a big drop over a high fence into a country lane below, which tries the nerve and skill of both horse and rider.

With the Monmouth hounds clean going, with big fencing and ditches, is encountered, but all the country being flat a fast pace is comparatively easy. The Richmond has furnished excellent sport on Staten Island, but has been very much interfered with by the rapidly growing suburban towns on the island—now a part of New York City—and the too liberal use of wire for fencing. This last is the greatest bane to the sport, as when it is rusted it is scarcely visible at a little distance. In places where it is used to strengthen weak fences by running a line along the top of the posts, it will turn a horse over in the nastiest of falls unless discovered in time to choose another place to jump.

The Meadow Brook country, on Long Island, made famous by its big fencing, hard riders, and very fast pace, suggesting steeplechasing to the visiting Englishman, is bounded on the north by the gently rolling and beautifully wooded Wheatley hills, which make an ideal hunting ground. Unless you are mounted on a first class horse and are prepared to jump five feet, at times, of cold, hard, unyielding timber, and to jump from the time hounds cast off and all through the

run, you need not start. As much of the land is fenced to keep stock in, it takes a deal of jumping, both clever and bold, to "go" the country. Many a visiting sportsman from abroad who thought he knew it all has acknowledged having his breath taken away by the line of big fencing that always loomed up in front after he had just safely negotiated the latest.

When the sport was in its infancy here, years ago, its followers pressed into service anything in the way of horseflesh that could jump a bit with a little schooling; but now the very finest hunters are bred with the greatest care from imported Irish and English stock. Native bred horses, too, often with good strains of trotting blood in their veins, are making excellent hunters; while numbers of Canadian animals are brought yearly to New York, selling at high prices at auction, according to their reputations. The ever increasing number of horse shows that are springing up all over the country fully recognize that the jumping and hunter classes are their chief attraction, and cause the greatest amount of enthusiasm, alike among those who never saw a horse jump before, as well as with the veterans who know almost every horse by name, remember his performances, and eagerly watch the work of newcomers in the ring.

If any one doubts the enthusiasm of the hunting man or woman for the sport, the excitement and exhilaration of the run, intensified by the spice of risk that you may break your neck at the first fence, and the sheer delight in afterwards talking it all over, let him tear himself away from business and the noisy turmoil of city life, and on the morning of some beautiful October day take a Long Island train to the village where the meet is scheduled for that day. On the ferryboat, generally up forward in the open air, he will find several men in long covert coats, with perhaps a suggestion of a pink collar disclosed, carrying big English bags, and with a pair of spurs sticking out of some pocket. They are chatting gaily with a party of well groomed women, who all seem to know one another very well. In the cars they are joined by others of their kind, and horse talk reigns supreme—the prospect of a big run; debates upon the question whether the

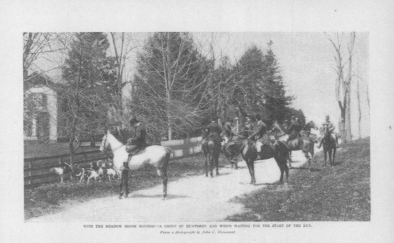

WITH THE MEADOW BROOK HOUNDS—A GROUP OF HUNTSMEN AND WHIPS WAITING FOR THE START OF THE RUN.

*From a photograph by John C. Hemment.*

going will be heavy or not; whether the country will be as "blind" as last week, owing to the leaves still remaining on trees and hedges; whether the "kill," or finish, will be in time for the late afternoon train back to dinner in the city; and all the delightful speculations that the possibilities of hunting can call forth.

At the little railroad station, at some crossroads, usually so quiet and sleepy, with the proverbial country store and its loungers hanging around, now even the ticket agent, with all the rest, has assumed an unwonted air of interest and curiosity. Handsomely appointed traps are picking up their friends; a superbly horsed break appears, carrying a gay crowd, while little road carts with sporty looking polo ponies are flying hither and yon. Over against that long row of sheds a dozen or more hunters are being held; girths are tightened, and owners mount, while up the road, coming in twos, are other hunters being led to the meet, hooded and blanketed. Greetings are being exchanged, and one constantly hears the inquiry, "What are you riding today, old chap?" Little handy legged grooms are scurrying around, ducking under horses' heads, and touching their caps at every order. A little way up the road can be seen the hounds, and the pink coats of the huntsmen and whips, who are all keeping strict watch, lest any particular dog should break away and the whole pack be off.

And now the master, riding magnificently mounted on a big, slashing bay, seeing every one ready, starts up the road. The horsemen closely follow—perhaps twenty or more of them—with a few grooms riding "green ones," horses that are to have their first experience in the hunting field after careful training over hurdles. Traps of all description fall in closely behind, mingling with a few young farmers in buggies, driving trotters. Up the road they all go for a mile at a slow trot, until, at a pair of bars by an old orchard, where the master has turned and raised his hand, every one pulls up. Many take advantage of the pause to tighten their hats on and to settle themselves more firmly in their saddles. The horses are restless at the restraint, until the huntsman, with a cry, deftly turns the hounds, and in an instant they are off through the orchard, while the riders

take their turn over the bars after the whips and the master. Through the orchard they scatter, the riders ducking and bobbing their heads to avoid the low branches.

The carriages, meanwhile, are tearing along the road, with their occupants eagerly watching for their first glimpse of the run. And now suddenly, parallel with the road, and two fields back, are seen the hounds streaming away in full cry, running so true together that daylight hardly shows between any of them. Over the post and rail fence the horses fly, to scatter somewhat over the field as a big four railer looms up ahead of them. Each man is mentally trying to pick out his particular panel, where he can jump at a safe distance behind others in front of him. Over they all are, although one big horse was heard to rap rather too hard for safety, and now they are all sailing away over a snake fence and up a hill.

"He's down!" was heard, as a thoroughbred was seen to turn a complete somersault and send his rider plowing into the soft earth. But the horse is up and off with his reins dangling.

"Is he hurt? Who is it?" is called from the traps.

"Yes, he's all right"—as the rider, hatless, is seen running across the field after his mount; but unless some man ahead can catch and hold the horse, the dismounted sportsman will be hopelessly left behind, so fast has the pace become.

The field is beginning to scatter, and those few men who always ride in the first flight are looking around to see how close behind their friendly rivals are, or to note the face of a newcomer with mingled curiosity and interest to see how he "goes."

Now they are lost to view, and after a mile or more along the road the carriages come to the first "check," the drag man having lifted the scent. The hounds are bunched around the huntsman and master, panting and lolling their tongues, while many of the riders have dismounted to ease their horses, which are covered with foam.

After a few moments' rest, up the road they start again, where the hounds are once more thrown off, the men following. Over hill and dale they go, sometimes appearing to the road riders as tiny specks in the distance, the touch of pink visible afar. Only a few of the carriages

WITH THE MEADOW BROOK HOUNDS—THE MASTER AND A WHIP LEAVING THE FIELD AFTER THE KILL.

*From a photograph by John C. Hemment.*

and the followers on horseback are to be seen, many of them having taken cross-roads that led them astray, and the pace having told on others. A few of the greatest enthusiasts, who follow every hunt, are waiting on the top of a commanding hill, where they know the drag man will finish the run.

There he is, in the middle of the field, with the "worry meat" in a bag, and the hound wagon is waiting in the road to drive the tired dogs back to the kennels. After a few moments the cry of the huntsman is heard away down in the woods, and soon the hounds emerge in a long line and surround the drag man, jumping and leaping for the morsels of meat held high in the air. And now a few of the best mounted and cleverest riders come in sight, and challenge the master for a final spurt to be the first in. The pace has been extremely fast, and a few have been "hung up," while others have missed the trail.

Quickly grooms are scraping out the dripping horses, while others are being blanketed and led to their different homes. The men, sometimes with scratched faces, or showing by the mud on their shoulders that they have "come a cropper," are putting on top coats, taking a pull at their hunting flasks, and praising their different mounts.

Soon they are on fresh mounts or climbing into their traps, and are off to that comfortable house over there, where the hunt breakfast is to be. As the men

slowly jog up, smoking and chatting, what a sense of healthful pleasure and delight they feel, and what high spirits they are in! The excitement and danger, with the satisfaction of coming through without mishap, can scarcely be equaled at any other time.

With some of the stains removed, and with famous appetites—and a healthy thirst, too—men and women are prepared to do ample justice to the collation. Afterwards, from the mere enthusiasm of excessive spirits and energy, there are hunting songs and informal dancing, winding up with a hunt quadrille. Too soon the time comes for the return to town. With all sorts of jolly adieus, the city visitors are whirled away to the station, in little traps, or in a break and four. And through the failing light and the hush of nature, in the quiet autumn evening, they go rattling by, past little country homesteads and quiet farmyards that were settling down to sleep. On the train the run is gone over again, each man asking the next if he took that "whopper" of a fence just before the finish, with the drop into the road.

After this day's experience, among the young fresh faces that glow with health gained from a pastime that calls out nerve as well as skill, if there is any one who still questions the charm of the sport, let him keep his pessimistic thoughts to himself; for no greater enthusiasts can be found than the men who ride straight to hounds.

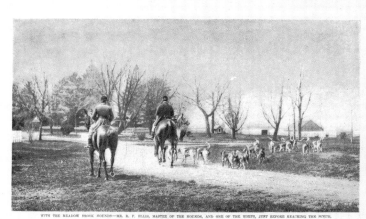

WITH THE MEADOW BROOK HOUNDS—MR. R. F. ELLIS, MASTER OF THE HOUNDS, AND ONE OF THE WHIPS, JUST BEFORE REACHING THE SCENE.

*From a photograph by John C. Hemment.*

WITH THE MEADOW BROOK HOUNDS—THE "RUN IN" AT THE FINISH OF THE HUNT. THE TWO LEADING HORSEMEN ARE MR. H. L. HERBERT AND MR. ROBY.

*From a photograph by John C. Hemment.*

# Index

## A

Allison, Thomas 37, *64*, 64, 65, 80, 85, 102

American Art Annual, 74

American Artists: Signatures and Monograms 74

Annual Exhibition Record of the Art Institute of
 Chicago 16, 74, 80, 81

Art Sales Index 74

## B

Baily's Hunting Directory 12, 18, 74

Balding, Bruce E. 6, *38*, *40*, 76

*Beagle Pack with Huntsman 53*, 79

Belmont, August, Jr. 38, 90-91, 93

*Blackwell, Mrs. James* 2, *12*, 67, *68*, 76, 79, 98

*Blue Ridge Hunt* 54, *56*, 79

Box Farm 5, 71, *71, 72, 73*, 93

Brook, The 11, 71

## C

*Caricature of Richard Newton, Jr. 22*, 23

Cattistock Hunt 63, 79

Chamberlain, J. I. 7, *12*, 31, 74, 75, 90

*Christalan 14*, 17, 57, 75

Christmas card (Richard Newton) 65, *65*

Clarke, Grace 5, *13*, 20, 22, 24-30, *26, 27*, 39-
 40, 44, 47- 49, *51*, 72-78, 84, 86, 91, 97-100

Clarke, T. B. 19-21, 25, 26, 37, 48, 58, 78

Clarke, T. B. Jr. 23, 27, 28, 47, 80

Cockroft, Mrs. E. T. 61, 78

Cocktail (see Nicoll, B.)

Collins, Dr. Howard D. 39, *41*, 45, 48, 63, *63*,
 77, 79, 80, 84-85, 97, 102

*Country Life* magazine 13, *13*, 40, *40*, 50, 76, 78

## D

Danger (see Cockroft, Mrs. E. T.)

Davenport's Art Reference & Price Guide 74

Davis, Joseph E. 30, 34, 37-39, *40, 42*, 44, 65,
 76, 85-86, 100, 102

Devilkin (see Wadsworth, Major W.A.)

Dictionary of American Painters 74

## E

Essex Hunt 19, 48, *49*, 78, 91

Ex-Libris (Grace Newton) *26*

## F

Fleitmann, Lida L. 22, *22*, 24, *24*, 25, 74, 80, 98

Foxcroft School 95

*Foxhound* (detail) *42*, 43

*Foxy Quillet* (see *Hunting Morn*)

## G

Genesee Valley Hunt 21, 75, 77, 88, 90, 99-102

Gerry, Robert Livingston 31, *36*, 76, 87

Geus, Mrs. Averill 5, 12, 67, 74

WITH BRUSH AND BRIDLE

107